50 ROBOTS
to Draw and Paint

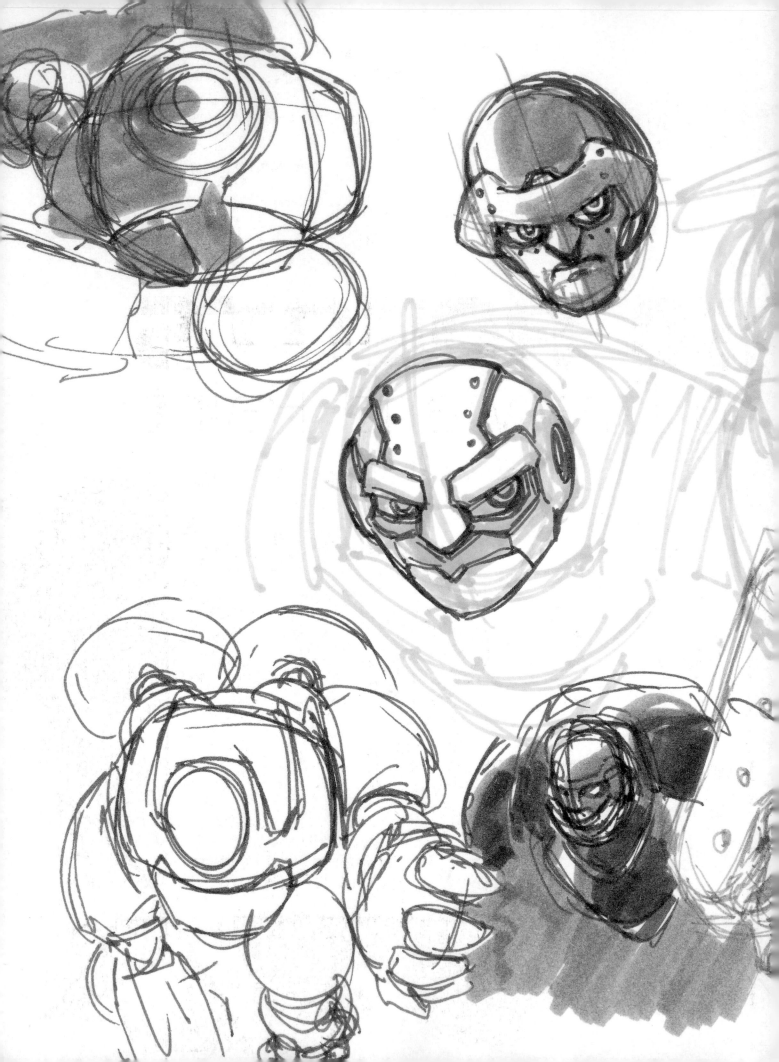

50 ROBOTS
to Draw and Paint

KEITH THOMPSON

A QUARTO BOOK
First edition for North America published in 2006
by Barron's Educational Series, Inc.

All inquiries should be addressed to:
Barron's Educational Series, Inc.
250 Wireless Boulevard
Hauppauge, NY 11788
http://www.barronseduc.com

ISBN-13: 978-0-7641-3310-7
ISBN: 0-7641-3310-1
Library of Congress Control Number 2005923520

QUAR.FRO

Conceived, designed, and produced by
Quarto Publishing Plc
The Old Brewery
6 Blundell Street
London N7 9BH

project editors: Trisha Telep, Lindsay Kaubi
art editor and design: Claire Van Rhyn
copy editor: Chris Middleton
assistant art director: Penny Cobb
picture researcher: Claudia Tate
proofreader: Christine Vaughan
indexer: Pamela Ellis

art director: Moira Clinch
publisher: Paul Carslake

Manufactured by Universal Graphics PTE Ltd, Singapore
Printed by Star Standard Industries PTE Ltd, Singapore

9 8 7 6 5 4 3 2 1

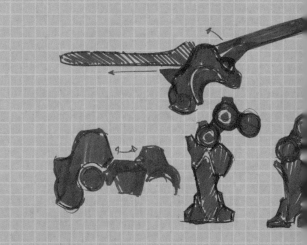

CONTENTS

In 1921 Karel Capek wrote the play R.U.R. in which he took the Czech word "robota," meaning "enslaved labor," and adapted it, creating the term "robot." We live in a time in which robots are becoming pervasive, and yet the robot is still primarily regarded as existing in the domain of science fiction. **Robots are unique in this respect**, straddling the realms of fantasy and reality. Although they exist in our world, the word "robot" tends to immediately conjure up impressions of futuristic technology or fantastical alchemical achievements.

 This book is an expansive reference for both beginner and experienced artists interested in creating their own robot art. To start, the book details robot-art basics, giving you a familiarity with general techniques and approaches that can be readily applied to most types of art.

 Many of the robots have been created by artists other than me, with their own opinions and methods. Some of these artists work traditionally, others digitally, and some, as I do, use a combination of the two. While the terms and tools may differ, the artistic advice is applicable to any robot artwork. Don't be afraid to simply copy what you find here.

P.S. You may want to destroy all
 your art when the robot uprising
 occurs, as these insensitive
 "mechanist" caricatures will
 be greatly frowned upon.

—Keith Thompson

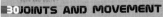

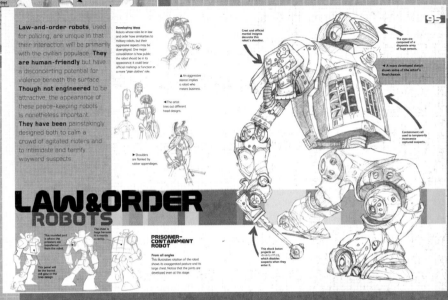

◄ Nuts and Bolts

This section explains construction and how to conceptualize and render generic robot parts. It offers an overview of elements you may wish to develop specifically for your own robots, and it discusses everything from joint and limb construction to props and tools.

Sketchpads ►

Sketchpad pages introduce subsections in the "Robot Foundry" (see below). See how illustrators develop ideas and get them onto paper.

Alternate views and rotations let you see the pared-down elements of each robot design.

◄ ▼ The Robot Foundry

The core of the book, this part describes and demonstrates how to draw and paint fifty robots. The text and visuals guide you through the robot's artistic construction, explaining different points along the way. You'll be told what the robot is, where and when it exists, and what it does.

Each robot is broken down into primitive shapes, so you can easily see the basic construction and recreate it yourself.

Discover the conceptual process that went into imagining the robot and developing its appearance.

Step-by-step description of the drawing and painting process.

8 INSPIRATION

Robots have always captured peoples' imaginations. The alchemists of old were obsessed with the idea of the homunculus: an artificial being created by humans; a robot. The popularity of robots has grown as we approach the age where they are actually coming into being.

In any subject, there is a wealth of artwork and creativity available to those willing to look for it, and collecting a body of inspirational material is an absolute necessity for the practicing artist. Simply looking through much-admired art can open up the creative process, allowing your ideas to develop in all sorts of fantastical directions.

Novels and short stories also offer creative inspiration. Reading provides an excellent opportunity to begin visualizing and creating illustrations to go with the amazing stories you've just read.

USEFUL WEBSITES

There's so much useful information for artists on the Internet that anyone can do a search on their own to find a wealth of inspiring material and information.

www.artlex.com
thousands of art term definitions and examples

www.artrenewal.org
the Internet's largest on-line museum

en.wikipedia.org
a great place for researching your subject matter

www.spectrumfantasticart.com
the best in contemporary fantastic art

www.eatpoo.com
an art site with an active and skilled forum of artists

www.cgtalk.com
on-line forum for the computer graphics industry

www.cgchannel.com
online magazine of computer graphics and effects

www.sijun.com
an inspiring forum of artists discussing their work

www.conceptart.org
some of the Internet's most imaginative artists

www.gfxartist.com
a great collection of artist managed on-line galleries

www.epilogue.net
high-quality site of fantasy and science fiction art

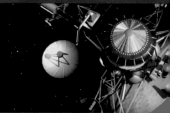

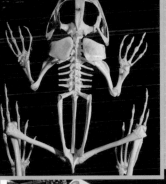

Zoology
Take inspiration from scientists: adapt the efficient and complex evolutionary structures found in nature for use in your robots.

Documentaries
Want to develop a tank robot? You should probably have a look at some documentaries featuring existing tanks before you try to create your own version from scratch.

Books
One of the the best sources for conceptual inspiration, reading books is a fantastic way to exercise your mental-visualization muscles.

Cinema
With the potential to be the most inspiring and engrossing of all media, cinema should not be overlooked.

Internet
As long as you are prepared to do some thorough searching, the Internet can be a great source for robots.

Graphic novels
A gold mine of extremely original robot reference and inspiration, graphic novels, as well as Manga, tend to be exceptionally well-versed in robotic art.

10 DRAWING AND RESEARCH

Classical art schools once stressed to pupils that one of the best ways to learn to make art is to study pre-existing art. It's also true that simple, repetitive practice can reap great results.

Life drawing is one of the prime staples of art education. Although the drawing of nude figures may seem to be somewhat disconnected from the production of robotic art, it is a necessity. You will need to understand the three-dimensional form and its interaction with the environment in order to gain a mastery of rendering structure in all kinds of art.

Maintain a consistent portfolio of current artwork at all times. Aim to replace your least favorite pieces and "clean house" occasionally to continually improve your portfolio. Research and explore new areas; constantly bombard yourself with inspiration from unlikely places. You never know when inspiration will strike.

RESEARCH

The most outlandish designs always require a believable grounding in reality. This basic believability adds support to the weird and wonderful, and research is a necessity in science fiction. Proper research methods help an artist to form a more well-developed visual vocabulary and to create an image library from which he or she can draw in the future.

The Internet

Easily the most streamlined and efficient resource, often one can find almost immediately more than one needs. An organized collection of bookmarks that grows over time can become a personalized library that the artist revisits with familiarity. Applications available for download or purchase can allow the artist to save whole galleries and webpages and then to customize them as a unique data bank for reference.

• One of the best tools for visual research is the image search engine. Always make sure to go through the

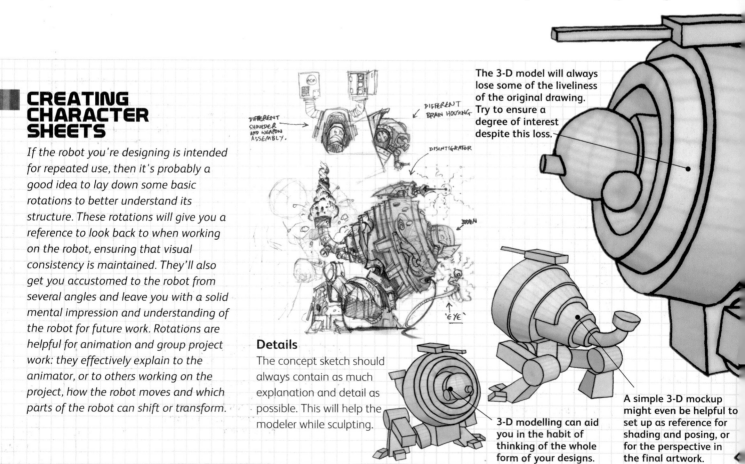

CREATING CHARACTER SHEETS

If the robot you're designing is intended for repeated use, then it's probably a good idea to lay down some basic rotations to better understand its structure. These rotations will give you a reference to look back to when working on the robot, ensuring that visual consistency is maintained. They'll also get you accustomed to the robot from several angles and leave you with a solid mental impression and understanding of the robot for future work. Rotations are helpful for animation and group project work: they effectively explain to the animator, or to others working on the project, how the robot moves and which parts of the robot can shift or transform.

DIFFERENT SHOULDER AND WEAPON ASSEMBLY.

DIFFERENT BRAIN HOUSING

DISINTIGRATOR

BRAIN

'EYE'

The 3-D model will always lose some of the liveliness of the original drawing. Try to ensure a degree of interest despite this loss.

Details
The concept sketch should always contain as much explanation and detail as possible. This will help the modeler while sculpting.

3-D modelling can aid you in the habit of thinking of the whole form of your designs.

A simple 3-D mockup might even be helpful to set up as reference for shading and posing, or for the perspective in the final artwork.

advanced image search option. Set the image size to "medium" or "large." This will ensure that the results are usable as visual reference.

• It's usually a good idea to be overly specific in the search field at first and then to generalize if more results are needed. Try many different variants if results are poor.

• Using +, -, and "" modifiers can help narrow down the search (see the search engine FAQ or tips section). Scan through the thumbnails presented until something catches your eye.

• Chances are that when you find a great image, the page it's from will contain more of what you're looking for, so don't forget to look around If there's more to see. It's great to find images using the search engine, but finding a whole website that addresses your research goals is what you really want. The site might also have a section of links to other, similar sites.

Libraries/bookstores

A good, image-heavy book can give an artist immediate access to a number of high-resolution images. A few good books, as applicable reference, are truly invaluable to an artist's work. Although the task of finding exactly what one needs can be both tedious and expensive, the payoff is always worth the hunt. When a good reference book is found, the artist has acquired a resource that can be consistently returned to.

Life observation

Technically, this method of research will always bring the best results. The problem is the artist's ability to acquire first-hand access to the place or situation needed. Time is also a constraint when using real-life as reference. People and still lifes tend to be the best subjects for personal observation as a method of reference and research.

Practice drawing
Simply producing frequent representative drawings is a perfect way to practice. Keep a notebook and draw your robot from a variety of different angles and ever-changing perspectives.

A 3-D representation of your robot can also present proportion or design flaws not foreseen during the 2-D development.

Text notes
Scribbling written details and notes can be the quickest way to lay down ideas or expand on a visual element in the art.

The 3-D form should encapsulate the form of the robot, giving a slightly chunkier overall look to the piece.

Keep close notes on scale, because a 3-D model quickly becomes divorced from any frame of reference.

EXTERMINATOR ROBOT.
THIS ROBOT IS DESIGNED TO HUNT DOWN AND EXTERMINATE ENEMY 'ORGANICS'!

GUIDANCE FOILS

ORGANIC LOOKING EXTRUSIONS VARY AMONG INDIVIDUALS.

OBVIOUS METAL EXO SKELETON

STABILISING RODS. (HOUSING STRINGS OF GYRO-ADJUSTORS)

PRIMARY WEAPON

HEAT SENSITIVE 'SEEKER' ORGAN, MOUNTED ON RETRACTABLE, PRE-HENSILE FLEXI-METAL PROBOSCIS.

ANTI GRAVITY GENERATORS HOUSED INSIDE BODY CASINGS

SENSOR CLUSTER

ALTERNATIVE GUIDANCE FOIL

5 METRES SCALE

12 WORKING TRADITIONALLY

Traditional mediums possess an inherent advantage over their digital counterparts: visual complexity. The algorithms involved in imitating a pencil's line on a computer cannot yet come close to representing the complexity that a pencil on paper can produce (eventually this will be overcome). By simply scanning the image, a slight choke point is introduced and some of its complexity may be lost. Certain tasks (masking, for example) present no material advantages in traditional procedures and should be relegated solely to digital process. Traditional and digital mediums should be recognized as noncompetitive elements serving differing roles, appropriately matching the desires and needs of the artist. The digital line may be far more valuable to some artists as it concerns smooth workflow and spontaneity, more so than the immediate aesthetic advantage derived from traditional linework.

▶ **Trade tools**
Blue Col-Erase can be used in a traditional, or a mechanical version.

TOOLS
Blue Col-Erase pencils
Commonly used by animators, blue Col-Erase pencils are available from several different pencil manufacturers. They're distinct from graphite in that they are far less disposed to smudging and smearing. When scanned, their color can be desaturated and resaturated in whatever hues the artist desires. A wide range of colors are available in Col-Erase, but differing binders and pigments can result in a noticeably varying softness and feel to the pencil (experiment, keeping in mind that the actual color of the pencil is unimportant).

Pencil extenders
Simple pragmatism: with extenders you can run your pencils down much farther. Avoid using them for sweeping, gestural drawing as their balance and ergonomics leave something to be desired.

◀ **Imbalance**
Don't use an extender on a long pencil. It will add too much weight.

Erasers
Relatively standard white eraser refills are made both for normal holders, and for electric erasers. Ensure the quality of the eraser before buying because it can vary widely. Good quality eraser sticks tend to be whiter and softer than their extremely poor, harder and yellower counterparts. The regular holder can be useful for immediate and precise erasing, but be sure that the tip is clean to avoid smudging. The electric eraser spins the tip of the eraser and is an extremely fast and efficient way of erasing heavy pencil work, while still being quite gentle on quality paper.

All shapes and sizes
Find your personal preference among the many types of erasers available.
1 Electric eraser
2 Beveled eraser in holder
3 Standard eraser
4 Gum eraser
5 Putty eraser

1 2 3 4 5

▲ Tint and texture
❶ Textured, handmade paper
❷ Smooth white paper
❸ Watercolor paper
❹ Tinted paper

Paper
Pictured here is a variety of 116lb paper, all of it good quality, with a slight texture. Again, experiment with different papers to see if you prefer a smoother or rougher texture. Paper should be heavy and tough enough to handle repeated erasure and drawing.

Electric sharpener
Ensure that it's the helical variety and not simply a rotating blade. While certain pencil tips (soft-edged, etc.) are better achieved with a craft knife, a good quality electric sharpener is extremely useful for general sharpening (especially in batches).

Masonite board
Experiment with different types of board to find the drawing surface that suits you best, one that's resilient enough not to bend.

▼ Base of operations
Choose a base that suits the weight of pressure you use with your pencil. Wood or plastic may be too hard.

▲ Extra sharp
If you find the electric sharpener insufficient, use some emery board to touch up the end of your pencil.

HELPFUL TIPS
Little tips like this can, cumulatively, save huge amounts of time, time that can be spent on actual artwork and not the frustrating minutiae of the craft.

• It's a good idea (beforehand) to have a series of pencils already sharpened and sharpened for differing roles (while it only takes a moment to sharpen a pencil, it still can break artistic momentum).

• Mount artwork on a series of masonite boards. This keeps the artwork backed with a surface to draw on, in case you want to shift locations, and can avoid damage being done to the paper.

• Some artists tend to hate categorizing things and cleaning up areas of high activity. However, a simple well-designed system can help manage a balance between structure and spontaneity. Without one you're eventually going to lose something or need to hunt for something while working on your art. This effort can either be expended beforehand, or you can leave it until you're on a roll and have to break it to find a replacement eraser.

HOW TO SET UP YOUR WORKSTATION

Light source positioning is important when you're working traditionally. You'll want a bright light source coming through your windows from about a 10 o'clock position (if you are left handed, from 2 o'clock). This will minimize cast shadows falling over your work.

The larger and cleaner the working surface, the better off you are. Have everything prepared and within immediate reach without cluttering the work space. If using paints, or anything that gives off fumes, ensure you're working in an extremely well-ventilated area.

14 WORKING DIGITALLY

When working digitally, it is a good idea to proceed in batches. If you are working on several projects at once, leave tasks to be done collectively. Scanning a series of drawings all at once saves time compared to setting up individually for each piece of art. Even for more manual tasks, such as digitally cleaning up the scans, it can save time if the work is done serially (one tends to gain momentum in laborious tasks, and it's a good idea to use this built-up momentum efficiently).

HOW TO ORGANIZE YOUR FILES

Keep computer files alphabetically ordered. Remember, with numbers, to keep a zero as a placeholder for numbering systems in series that reach at least double digits (11.jpg will be listed higher than 1.jpg, but not 01.jpg).

Monitors

Your computer will depreciate rapidly over time but a good monitor will be just as valuable as the first day you bought it. A multi-monitor setup is an excellent way to expand your working space, and is suprisingly easy to set up.

HOW TO SET UP YOUR DIGITAL WORKSTATION

When working digitally, you'll want no light source but that coming from your monitor. Glare and reflections dramatically reduce your ability to see subtleties on the screen. If working for an extended period, take breaks and go outside to view objects at varying distances, otherwise your eyes may become extremely strained, resulting in problems focusing and headaches. Choosing the right chair can be extremely important. It ensures that your posture isn't too bowed when working: back problems or even compaction of the lower organs can develop. Repetitive strain injuries can be avoided by regularly switching from the tablet to the mouse while working. Intermittently switch projects if rote processes are required.

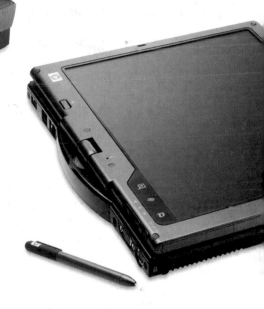

◄ **Gateway**
The scanner is your gateway
from traditional to digital.
Ensure that the quality of your
traditional sketches is not being
lost in translation.

TOOLS

Scanner

Avoid scanners that are thin, or
tout speed as a prime feature.
Apparently, the heavier the
scanner the thicker its glass
plate, which can improve the
quality of the scan. Be sure
the light is off when not in
use; this can save wear on
the bulb and preserve scan
quality. (There are usually
bulb-saving features that
automatically turn off the scanner, but
they can be unreliable. It's a good idea
just to unplug the power from the
scanner when not in use; this means
the scanner has to warm up when it's
turned on, but the increase in longevity
is worth it).
Although you may want to scan
strange materials for use in art (wood,
roughly painted textures, etc.), be
careful you don't scratch or mark the
glass surface in the scanner.

Tablet

Although there's still a lot to be
improved upon in terms of technology,
the tablet is a necessary tool for
working digitally. Experiment with
tablet sizes, but because a degree of
visual disconnection will always be
present, a larger tablet might not be
worth its ungainly size or the
impediment of having to use the
keyboard and mouse in conjunction
with the tablet. On multi-monitor
setups, ensure that the tablet is
designated to work only on the
primary monitor. Use a mouse to
access secondary displays.

Tablet PC

These may be seen as an alternative to
desktop PCs, or as an accompaniment
to your main workstation. Although
this model has no pressure sensitivity,
being able to draw directly on the
screen has its advantages (especially
for tedious labor, such as masking an
image). With a wireless network, all art
files can be kept in a shared file on a
main computer and accessed from the
laptop with ease. This avoids constant
file transfers and the attention paid to
which computer holds the most
recently modified file.

Digital camera

Nothing fancy is necessary here: a
cheap digital camera is excellent for
setting up reference shots. Examples
could be how light falls in from a
window, references for foreshortening,
and perspective references.

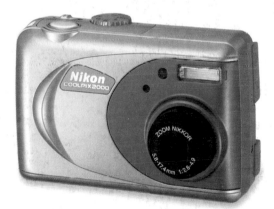

▲ **Digital sketchpad**
A tablet PC might be exceptionally
helpful to the artist who works in a
completely digital medium.

▲ **Picture quality**
For taking photos to use in your art,
it's best to invest in a top-of-the-line
camera, but for reference snaps, a
handy digital will be your best friend.

◄ **Tablet**
Although there's a lot of room
for technological improvement,
a basic tablet is still a necessary
tool for most digital artists.

16 ARTISTIC RENDERING

You will develop your own way of executing specific techniques, and the culmination of your differing approaches will give your art a distinctive thumbprint and style. However, before you can use them to your benefit, first you must grasp the fundamental functions of these basic techniques.

Contour lines

At first seeming formless, notice how closely these loose lines conform to the lines in the next step.

Remember that, although flat and two-dimensional, the curves of lines can convey a great deal about the form, which will become even more apparent later in the process. All other steps rely upon the quality of the contour line.

Loose line

1 Don't be afraid to draw forms overlapping each other: as long as the line is light it can be worked out later.

Tight line

2 Go in with a precise eraser and remove any overlapping lines that remain too apparent.

Hatching

Line hatching should always seem to lie on top of the plane it's texturing or shading. If the plane has a bump, or shifts, the hatching should follow this shift identically.

Cross hatching is a secondary application of hatching that coincides with the initial application. While traveling at a different angle, the second set of hatching must conform to the surface of the plane just as much as the first.

Hatching

1 The trick is to allow your motor skills to keep the lines consistently spaced and relatively smooth.

Cross hatching

2 If you stiffen up and try to be too precise with the hatching, the lines will become wavy and stilted.

Shading

Mainly functioning to bring texture, this light hatching is also prevalent in areas of high shadow.

If a plane shares the same angle, it should probably also share the same shading. An exception to this may include reflected light, or a differing material composition.

Line shading

1 Loosen up, but don't become careless with this application of linework.

Digital shading

2 Avoid attempting an overly dynamic contrast that may end up obscuring important details.

Highlighting

Although suitably shaded, this section can be given even more form by applying a layer of highlighting.

Additive tints of white run along raised sections of this robotic limb section. This highlighting adds more contrast and even seems to make the shading darker.

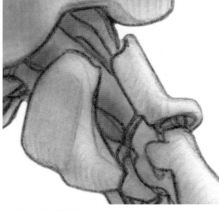

Basic highlights

1 Basic plane shades are achieved at this point, but you can punch them up a little bit more.

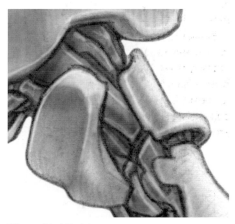

Sharp highlights

2 Your tight highlighting can end up developing even more complex forms in the robot's surfaces.

Glazing

Remember that the color of the entire piece before glazing will show through and affect how the glazes appear. A warm base tends to give the colors an attractive richness.

Note how much color variance results from a glaze; because it's additive, no color in the process is lost, only compounded.

Colored ground

1 Start off with a basic textural surface, including a slight degree of inconsistency and roughness.

Glaze coat

2 Be moderate with the shading and highlighting here. The metal is covered in a layer of paint, so there will be no glinting or strong metallic contrasts. The paint covers the entire material, and the indication of its original composition is primarily textural.

18 RENDERING MATERIALS

Being a manufactured entity, robots will usually be composed of several different materials that can often have widely varying appearances. Immediately one would default to simply assuming they're made of metal, but first take a look at a car and its materials: note the different types of metal, glass, rubber, and plastic. An inclusive material complexity is key to creating a believable and interesting robot.

Polished / Lubricated Metals

Shapes and structure
1 Not intended for heavy exposure, this material can be used for exposed internals and jointing.

Shade
2 Extremely heavy contrast is applied here with bright, crisp highlights.

Hue
3 Highly reflective, the material will include the colors of the surrounding materials. Highlights are extremely bright white.

METAL MANIA

Although a robot can be made of any material the artist desires, the classic form will probably have a mostly metallic composition. From the gleaming chrome public-service robot, to his rusted and pitted street-sweeper contemporary, metallic robots can have a vastly varying appearance. Both aesthetic and conceptual concerns will dictate what types of metal you choose for your creation.

Oxidized copper
Worn metal that's had a reaction take place on its surface will begin to show blotchy patching and a rough texture.

Punched aluminum
Some types of polished, clean metal surfaces will show a general gradient on its surface with highly reflective spots where the surface has changed (in this case, small studs).

Brushed stainless steel
Begin a surface such as this with a general gradient that would suit an extremely polished surface, but then distress it slightly for a less reflective, brushed look.

Copper
Notice the color shift on this metal: the distinct copper-orange isn't solely important. Offset it with a slightly desaturated purple as it moves into the shade.

Split, stretched steel
If a part of your robot needs freedom of movement or the ability to deform, you'll want to think of a pattern that allows for stretching and bending in most any direction.

Brass

Line

1 Being a bare metal, start off with some heavy darks. Leave clear areas for the later application of highlights.

Shade

2 When shading and highlighting, lay in basic planes and edging.

Hue

3 When colored, the distinct nature of the metal comes through. Highlights tend to be white, and the majority of color is gray. The transition from shade to highlight dictates the color for the whole material.

Gun metal

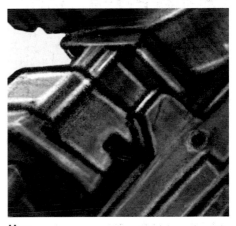

Line

1 Very strong lines are initially important here to ensure a machined appearance and dark contrast for the later steps.

Shade

2 Shading should be overall dark, with stiff and stark highlights only.

Hue

3 Remember that gun metal, though drab, will still reflect the hue of local colors.

Painted metal

Line

1 Start off with a basic textural surface, including a slight degree of inconsistency and roughness.

Shade

2 Be sparing with shading and highlights. The metal is covered in a layer of paint, so there will be no glinting or strong contrast.

Hue

3 The paint covers the entire material, and the indication of its original composition is primarily textural.

Shiny laminates

Line

1 The line work is serving the form primarily. Little indication needs to be given of the material at this point.

Shade

2 Notice that no distinct surface texture is used. The blurry quality and shine is simply the environment playing off the reflective surface.

Hue

3 The hue is mostly reflecting the lighting of the environment. Stark highlights next to slightly darkened strips glint and show off the reflective material.

Plastic

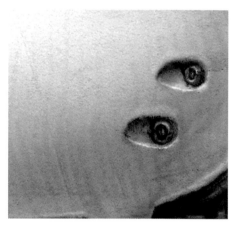

Line

1 Whereas initially textured much like painted metal, this is more for definition of form and will later be toned down heavily.

Shade

2 The shading and highlighting is gentle even for a slightly shiny plastic.

Hue

3 Here we can see how toned down the texture has become and how the glazed color is much more subtle than on the metallic surfaces.

DECALS AND LOGOS

A decal, or label, is simply a two-dimensional image laid onto a three-dimensional surface. A simple way to understand this is to imagine the decal contained inside a corresponding box or grid. When this box is laid flat over the surface of the object, the decal will curve and deform in a consistent manner to that of the box. Note how the curve of the containment box also corresponds to the contour hatching applied earlier.

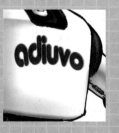

Convex
The decal bulges out over the robot's surface, its center stretching.

Concave
The decal curves into the depression of the surface on which it's imprinted.

Perspective 1
Lettering will diminish in size if the robot is turning from the viewer.

Perspective 2
Decals will conform to the perspective from which you draw your robot.

LIFE IS YOUR PALETTE

You can use pretty much any material that comes to mind to construct your weirder robots. You may have a great visual picture in your mind of a robot made of sponge. Just make sure that your backstory serves this initial vision. Don't be afraid to try things that may initially seem ridiculous. Use your imagination and do some research to make your implausible idea usable.

Overlaid pattern
The actual material may be unimportant if the robot is decorated with a pattern for ceremonial reasons.

Amorphous material
Your robot might be made of a clear material, like water, that can form shapes, and even function as aquatic camoflauge.

Stone
A golem or magically created robot may be made of stone or some other earthy material that's animated by a sorcerer.

Iridescent fiber
Materials such as iridescent synthetic fiber weaves give the impression of extremely sophisticated technology.

Ceramic
If your robot is heavily armored it may be plated in ceramics such as boron carbide, which offers incredible ballistic protection.

Wood
Some primitive robots may be constructed with wood, of which there are many variants. Choose an exact texture, color, and type.

Shells
Organic shells or carapaces may be vat grown and used in a partially organic robot, giving it the appearance of a crustacean.

Plastic
Plastics look deceptively easy to render, but their particular specularity and hues are often quite unnatural and difficult.

Foam
Soft foam materials can be used on robots that deal with people in a delicate fashion—a child's robotic nanny, for instance.

Transparent film
Lay a textured, plastic film over your robot's surface. Light and shadow will be the only things to indicate this near-invisible film.

Organic

Line
1 Loosen up and keep the shapes flowing. Line weight should vary greatly.

Shade
2 The shading handles more of the soft, smoothly textural surface, rather than using the line to achieve this.

Hue
3 A lot of warm color variation is used for the organic material, and a slight shine is given to indicate moisture.

22THE WHOLE PROCESS

On the following pages you will be guided in detail through every step involved in the process of creating a robot from scratch. This, of course, is only a single, specific way to go about things, and you should develop your own techniques, adding to or removing from the steps seen here. The following sequence combines drawing and painting.

LINEWORK

Don't be afraid if the thumbnail seems like nonsense to a regular viewer: what's important is that *you* understand it.

The thumbnail
1 The basic shapes and ideas of the robot are conceived in this step. Note the details that appear in this stage: the dual eyes are far more important to the design than the details of the arm mechanisms.

Some parts—such as the ammo drum—will undergo a slight change after this step.

Loose gesture
2 This step is basically laying in the proportioning at full-size. These lines will be carried through to the finished piece, so be gentle with line weight. Although it should follow the thumbnail closely, remember that the curves and shapes should also result in an improvement over the thumbnail's.

Loose Linework
3 Recognizable elements of the robot take shape at this point. Remember to keep the linework light in this step. Details that have not yet been conceived need to be developed at this point, so take your time.

The main mechanics and jointing is solidified (see Joints and Movement, p.30).

Although the drawing is coming together, don't get complacent.

Tightened contour line
4 The final lines are laid in at this step, and this contour will show in the final piece, so take care. All the major structures and details are rendered at this point, from the shape of the large leg plating to the internal sockets visible in the pelvic gap.

SHADING

Hatched, finished line

5 This step uses hatching and bolder line definition to add a degree of form to the flat drawing. Traditionally, this is the last step before scanning the image into the computer so make sure you're satisfied.

Highlighting will increase the readability of detailed parts.

Remember that it will be easier to remove linework in the computer rather than add it in after this step.

The shading should serve as an indicator of visual importance, as well as realism.

Shaded

6 After scanning, a transparent layer is set over the top of the robot. Black is applied in degrees of opacity to fill in planes that will be darker and cast in shadow.

Highlighted

7 A new layer is set over the top and tints of white are added in places that require highlighting. Many of the applications of highlighting are as much drawing as painting and are resultantly quite linear.

COLORING

Notice how the shading seems to lighten. The loss of white as a contrast creates this effect.

First glaze coat

9 Lay transparent washes of color over the robot, setting in large areas of basic hues.

The initial glaze coat may seem a little drab at this point.

Laying in a canvas ground

8 This is the step that really begins to blur the line between drawing and painting. Find a ground that suits your personal aesthetics (it could simply be a textured paper or canvas) and lay it, multiplied, over the drawing. This texture will set the color and textural harmony for the whole piece.

Try to avoid simply layering the same color again in this second coat.

CHOOSING A GROUND

Your canvas ground will affect the whole impression and style of your art, and choosing the right one is an extremely important step. Anything can be used, and its attractiveness to you and the suitability to the art are your primary concerns. Ensure that there are no large contrasts between light and dark as this will conflict with the painting later on. If you can scan it, it can be used as a ground.

Second glaze coat

10 This second, independent layer of glazing will deal with reflected light and deliver an added spectral complexity.

Finishing steps

11 This step will wrap up the finished piece and involves adding little details. Decal application should probably occur at this step, as well as slight saturation tweaking and visual effects such as LEDs and rusting or staining.

Decals can perform important functions of instant, non-verbal identification.

This inventory number is one of the only "personality" traits that distinguishes this particular Brainbot from the rest of its platoon.

Your Brainbot is now complete and ready to protect some important dignitaries.

26 DEVELOPING YOUR IDEAS

Work as small or as large as you prefer, but the function of this step is to lay down generalized designs as fast as possible while focusing on major elements and shapes. Often a thumbnail may be so minimalist that only the artist can make any sense of it; being able to construe the finished product from this step is an important skill. Of course, by no means should you limit yourself to the design produced at this stage, and if additive improvements are conceived, they should definitely be worked into the design as the art progresses.

Brass Lion: Dramatic progression

▲ Here we can see the dramatic progression occurring in the development of Her Majesty's Honorable Brass Lion (p.58). Initially starting as a more arachnid or bestial form, it was then modified to a humanoid shape.

Orbital Delegate: Evolution of function

Encyclical Purger: Similar re-workings

▼ ▶ Here we see many versions of the Encyclical Purger (p.102), all of which bear a close resemblance to each other. No real thumbnail was used as a final, and the completed piece takes elements from differing thumbnails; it also utilizes aspects not yet appearing at this stage.

▼ ▲ The Orbital Delegate (p.104) was initially more of an Orbital Paratrooper, seen here as a grounded soldier incapable of flight.

▲ The second step shows a rotated view of a similar soldier with extraneous gear for functioning in space.

► The hunched or curled posture seemed incongruous with the technology and the military flavor of the timeline, so a more erect version was developed that bears a closer resemblance to the finished piece.

CONCEPT DOODLES

Play with silhouettes of your design as an initial step. With this approach, you'll avoid getting bogged down in details too early.

Even in this rough treatment, the essence of the robot is captured.

▲ Small arrows can be seen as a reminder to further straighten the posture.

▼ In this design the robot has been altered to appear to function exclusively in orbit, losing any need for stability or a conventional soldierlike structure.

There is no problem making the leap from the early sketches and doodles to this fully realized robot. The early doodles are effective echoes of the final result.

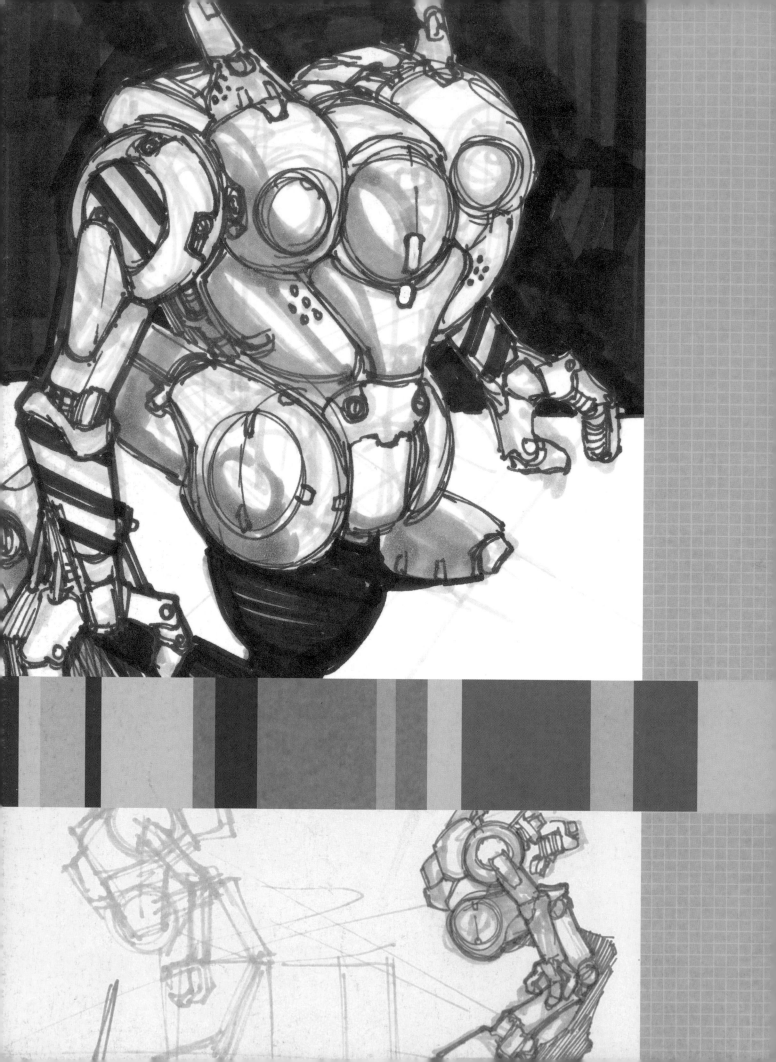

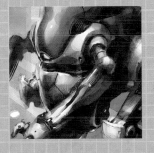

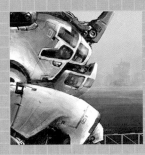

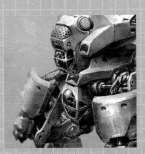

A robot is a sum of its parts. The details you decide to include in your construction are important in and of themselves. This section will guide you through the construction of jointing and articulations, through to the devices and tools attached to, or held by, your robot. These details will indicate to your viewer that your robot is lithe or lumbering, constructive or merely destructive.

NUTS & BOLTS

30 JOINTS AND MOVEMENT

Whereas an internal structure can be left unspecified, one absolute requirement must be adhered to: the limbs must move and perform their function without other parts of the robot interfering.

A robot with a bladed weapon will seem impotent if it's even slightly obvious that it cannot swing the weapon without cutting into itself. A robot with a gun will seem ineffectual if it appears that its range of fire is limited. Take time to imagine the robot performing its intended function (this is fun, self-indulgent, and extremely beneficial to the process).

Realistic joints
Combine mechanical elements with organic curves in your robot design. Notice that the mechanical elements remain bonelike, maintaining the joint's functional appearance.

PRIMARY JOINTS

Humanoid
With these basic joints, the robot should be able to function much like a human being. Of course, to dehumanize the robot, the head could be removed or set into the body, or the legs replaced with titanium tracks.

Hand
A humanoid robot's hand will probably follow human physiology quite closely, especially if designed to perform common human functions (all basic tool-use would require it). Note the jointing and, that while it could change on a robot, how the length of the fingers in relation to each other is very important. The middle finger is longest, with the ring finger often being next, followed by the index finger, and finally the pinky.

Humanlike movement
The red dots denote all the main points of articulation needed for a robot to function in a believable manner.

Nonhumanoid
Believable movement must be conveyed in even the strangest shapes and structures. Such a design might not resemble any preexisting form, but with the inclusion of these basic joints, it should conceivably be able to function.

Real anatomy
You can see in an X-ray of a hand that the bones are all shaped to perform specific functions and can be carried over into robot designs. Mix and match however you wish: for instance, repeat these finger joints eight times and use them as a reference for a spiderlike robot's legs. The thumb could be used as reference for a single, articulated gunmount that can move freely on its attachment to the robot.

JOINT STRUCTURE

Believable jointing is extremely important in a creation whose articulation is often open and uncovered for the viewer to see. Below, three main types of jointing arc illustrated that could be used in robotic articulation.

Hinge

Here is a simplistic mortise hinge, comprising two sections, with a lubricated pin running through them (check out your door). This is a good basis for more clunky or primitive robots and would have to be combined in sets of at least two to allow for a full range of motion.

Assembled hinge
Notice that the pin is flush with the end in the assembled piece.

Disassembled hinge
A hinge like this is made up of three mechanically simple parts.

Universal hinge

This variety of hinge allows for a wide range of movement contained in a single point of articulation.

Assembled universal hinge
Although supplying excellent articulation, this joint can appear structurally weaker that the mortise hinge.

Disassembled universal hinge
Only made of three parts, this joint is structurally complex nonetheless.

Ball and socket

Far more complex and potentially organic, this joint resembles how an animal's skeleton is jointed.

Assembled ball and socket
The ball and socket is more joint than hinge. The final limb will need extra elements for stability.

Disassembled ball and socket
A lubricated pad should lie between the connections in the ball and socket joint.

Segmented

Segmenting allows for a huge range of movement for a joint fashioned out of a hardened carapace.

Assembled segmented
Experiment with different versions of this joint: more armor means a stiffer joint.

Disassembled segmented
Make your jointing as long as you want by simply repeating this section.

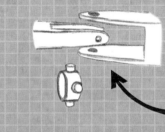

32 BITS AND WIDGETS

Choosing the proper type of screw head will be primarily up to your esthetic tastes as the artist. Some screws may be covered with caps that have their own shapes, others may lie flush with the surface. However, these esthetic choices should also match the storytelling associated with the robot—a highly sophisticated robot set far in the future probably shouldn't have big lug nuts on it!

Nut-head
Building your robots with chunky screw heads and visible bolts, can result in a grotesquely interesting character.

ASSEMBLY DETAILS

Screw heads
A robot, especially if mass assembled, may display extensive jointing using industrial couplings. In your designs, different screw heads can add variety and a touch of personality—for instance, a Phillips head may give a more complex and ornate appearance than a regular slot head.

Phillips head

Slot head

Square head

Add variety
Cars are mass produced (by robots!) to be uniform. Bring variety to your designs by varying the details.

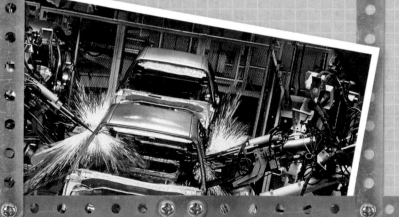

Concealed panels and sections
A robot may have limbs or parts that retract into its body when not in use. Remember that the covering plate must match the hole it leaves in the main body of the part. Also, the device contained within must appear to correspond with the space inside the area of concealment.

Curved and ratcheted
A workaday brace, such as this, would not look out of place on any type of robot.

When closed, this pod has a self-contained shape, useful for sleek, aerodynamic bots.

Open sesame
A visible rotating hinge gives the viewer an indication of how the nozzle slides out of the casing.

Instead of showing complicated internals, consider a concertina-style dust cover that hides them.

Anatomy as a structural base

Organic reference can be invaluable even for robots. This skeletal android leg structure follows human anatomy almost exactly, creating a believable basis for bipedal locomotion. Simply by replacing the organic tissue with an artificial counterpart, a perfectly human anatomical structure can appear strange and robotic.

Organic reference
Study human anatomy, look in text books and medical dictionaries, to get a sense of how human limbs function.

Mechanical skeleton
The differences depicted in the robotic bones are, visually speaking, only cosmetic. The materials are implicitly to be different, and the joints are posed as being mechanical.

The distinctive curves of human bones have been maintained here.

Artificial materials
The bundled fibers of the muscles have been replaced with tensile bundles of steel mesh cable (which would function quite similarly to muscles).

In principal, the muscles work identically to those of a human and wrap around the bone in the same configuration.

Piping and wiring

The piping or wiring in a robot can vary widely for aesthetic or storytelling reasons.

Wire mesh
This cable is protected by a strong steel-fiber mesh that still allows a degree of movement.

Segmented
Jointed plates surround this wire to protect it from harsh conditions or situations.

Bundled
This set of bundled cables is composed of several smaller wires bound with plastic rings.

Curled
This wire has been curled up in a spiral to minimize length while still allowing for a large degree of extension.

Ribbed
This piping has been strengthened with hardened rings, creating a more rigid and sturdy type of piping.

Smooth plastic
Simple and bland, this type of piping may be used to avoid visual confusion in areas with a high degree of structural complexity.

Wire mesh

Segmented

Bundled

Curled

Ribbed

Smooth plastic

34 ATTACHMENTS AND EMBELLISHMENTS

A basic humanoid robot can be interesting, but it may lack the storytelling element that a more functionally obvious design can provide. An artist should always think about what his or her creation would do in the world in which it exists. Added attachments and embellishments present narrative elements that dramatically enhance the appeal of the robot's design.

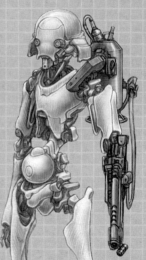

Modification sketches
By making quick sketches of potential robot modifications, you may come up with something that will influence your final design.

BASIC FRAME
The basic frame of a modular robot. Humanoid for design and application reasons, this robot is presented with basic functionality and the potential for a vast number of modifications.

This basic humanoid robot has no obvious specific function, as it hasn't yet been specialized.

The communications fixture is situated at the highest vantage point on the robot.

Communications
A communications array protrudes from the skull of this robot. Two primary antennae slide on a disk mounting, and a coil housed in the lower extension aids transmissions. Note that parts of the robot have been removed (part of the skull dome) which brings a further level of design unity to the additions.

Antipersonnel functions
The left forearm of this robot has been replaced with a napalm thrower. The napalm supply leads from the expansion chamber in the body of the thrower up the piping to a large tank anchored to the robot's left shoulder and scapula. The separation of fuel and weapon adds a level of visual complexity to a simple modification.

The napalm thrower is about the same length as the replaced arm, ensuring ease of clearance when in use.

Survival

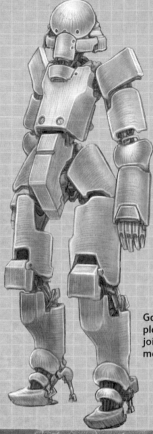

Fully plated in heat resistant, magnetized ballistic plating, this robot has been outfitted to survive extremely hazardous situations. The armor lays on, and curls around the profile of the robot, and still maintains the necessary gaps in jointing for movement.

Gaps in the armor plating allow the joints to flex and move freely.

Reconnaissance

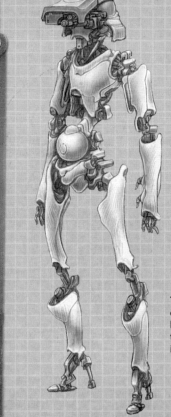

A large, extended visor gives this version of the robot extremely advanced visual functionality. A primary cluster of lenses on the visor's left side telescopes and rotates, enabling the robot to see in a variety of ways. In some cases, this capability is limited only by the curvature of the earth.

This fixture could potentially be removed by the robot itself in the field.

Supply

This version has attachable carrying cases. Several compartmentalized portions are detailed, and a relative front and rear balance has been maintained in the whole structure. This robot could simply be a pack mule, or the cases may contain a huge mainframe that vastly enhances the robot's cognitive and calculation capabilities.

The cases are attached around the pelvic region to lower the center of gravity and make the robot more stable.

Scout

This robot has been fitted with three back-mounted jump jets. A brace crosses the chest plate for extra anchorage, and the jet openings are socketed and spherical, pivoting in all directions. The jet openings should extend outward from the body of the robot to allow for proper clearance.

The jets need the appearance of having a high range of directionality, or the viewer will envision the robot simply careening into a wall from lack of control during flight .

36 MILITARY ATTACHMENTS

To carry out its intended function, a robot will need tools that may or may not be integral. The weapons that an offensive robot will carry can speak volumes about the robot's intent, function, and even personality (in a specific sense of the word). For the sake of functionality, a robot may be fitted to use interchangeable, modular weapons, allowing for a wider range of application. These two pages illustrate how a basic design can be adapted to fulfill whatever role the artist wants for the offensive robot. The following weapons are intended for use by a humanoid, mass-produced robot.

Balancing act
When designing a weapon, think about how it will affect the robot's center of gravity.

GENERAL PURPOSE

Here is a basic assault rifle; its frame and receiver will remain consistent in all the following derivations. Standard issue, and with a universal application in mind, this frame presents a basic weapon for infantry use.

This gun would be used by basic, humanoid robots.

CLOSE SUPPORT

An independent, under-barrel 40mm grenade launcher has been attached to this rifle for grenadier robotic infantry. An extended iron grenade sight points up from the gun frame. An opened trigger frame extends down to the base of the grip, allowing the weapon to be used by a robot with digits thicker than the average human's.

A robot with a strange, or simply large, hand configuration would need a trigger guard like this.

HEAVY SUPPORT

A large box feed of belted, tumbling rounds replaces the old magazine, and a downward directed flash suppressor and bipod are fitted to the end of the barrel. A carrying handle is fixed to the top of the frame for aid in laying down large swathes of suppressive fire.

Depending on the size of the robot, it may not need to always have this gun deployed prone for use.

SNIPER

An extended barrel offers more rifling for enhanced accuracy, and the scope jacks straight into the processor of the robot. The magazine has been shortened to better facilitate prone shooting, and the standard grip has been replaced with an actual robotic hand fixture for the sake of immediate and enhanced trigger pulls. The hand fixture would attach straight to the wrist of the user robot.

This scope would require a matching female port on the robot to be plugged in.

CQB/SECURITY

This version has been rechambered for pistol rounds, and the barrel has been drastically shortened. A slanted foregrip has been installed to control climb, and a sliding stock has been fitted (seen unextended here). This version of the weapon would be used with concealment in mind for close-quarters security roles or for use by robotic tank and artillery crews.

The smallest of all the variants, the short barrel means it is only useful for close firing.

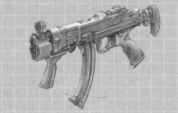

PARATROOPER

A ceramic bayonet is affixed to the front of the shortened barrel, and a folding stock can dramatically shorten the overall length of the rifle when needed.

This would be used by a lithe robot that needs to move swiftly on the field.

BLACK OPS

This rifle is for clandestine and internationally illegal roles in assassination and hostile-territory reconnaissance. A large, baffled sound suppressor surrounds the shortened barrel. The magazine is an under-barrel helical system housing fifty rounds. A padded brass catcher covers the ejection port, silencing the action of the chamber and collecting bullet casings to lessen forensic evidence.

It's fine to make a strange looking gun, but try to keep its function in mind.

Swordsman

Not all weapons need to be guns. In this sketch, this combat robot leans forward, left fist aggressively clenched, right fist grasping a a long military saber, ready to swing. The best way to draw authentic looking military weapons, and to find interesting inspiration, is to do research by looking at historical military styles in museums and books.

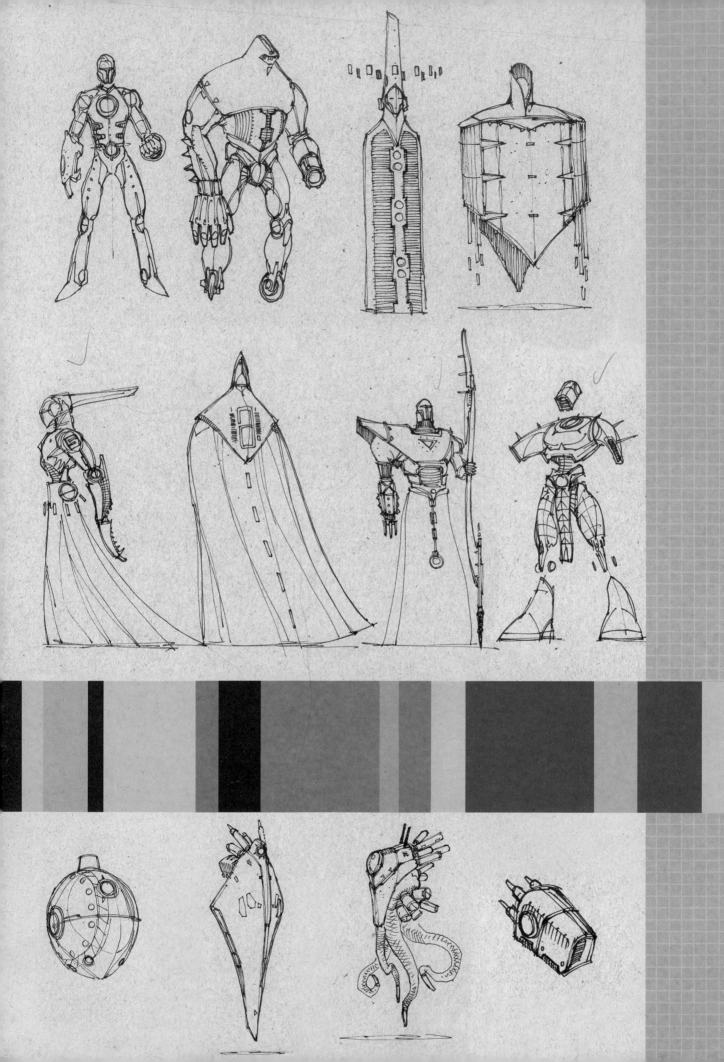

This section describes and demonstrates how to draw and paint 50 robots. The text and visuals guide you through each robot's artistic construction, explaining different points along the way. You'll be told what the robot is, where and when it exists, and what it does. There are step-by-step sequences that let you see the creative process, and each robot is broken into primitive shapes, so you can see its construction and easily recreate it yourself. Some basic robots are shown at the beginning of this section. Start with these.

ROBOT FOUNDRY

Mass-produced and structurally simple, some robots are created only to be easy to use, cost effective, and relatively disposable. **These robots offer** a great opportunity for you to become familiar with the fundamentals of robot art. **Sparse detailing** and a basic physiology, allow you to develop a vocabulary of core techniques that will also come in handy for creating more complex robots.

Variations
Simple robots allow for a wide range of approaches that can be attempted and discarded quickly. This immediacy can result in some pleasantly unexpected designs.

◀ This robot appears a bit too much like a creature that has dressed itself up to imitate a robot.

◀ This design has cartoonish bends in its posture.

▶ A jaunty pose and a slight smirk give this robot too much of a cartoonishly human character.

◀ While stable, this robot's leg configuration suggests movement might be difficult.

BASIC
ROBOTS

A good design should have a lot of character even when viewed from the rear.

For a robot this rotund, ensure that the arms are long enough to reach around its girth!

Parts of your robot, such as this visor, may be so simple that they have to be manually operated.

STOCKY ROBOT
From all angles
Play up your visual decisions when creating your robot: if you want a stocky, fat robot, then details such as short, lumpy legs will add to the effect you're looking for.

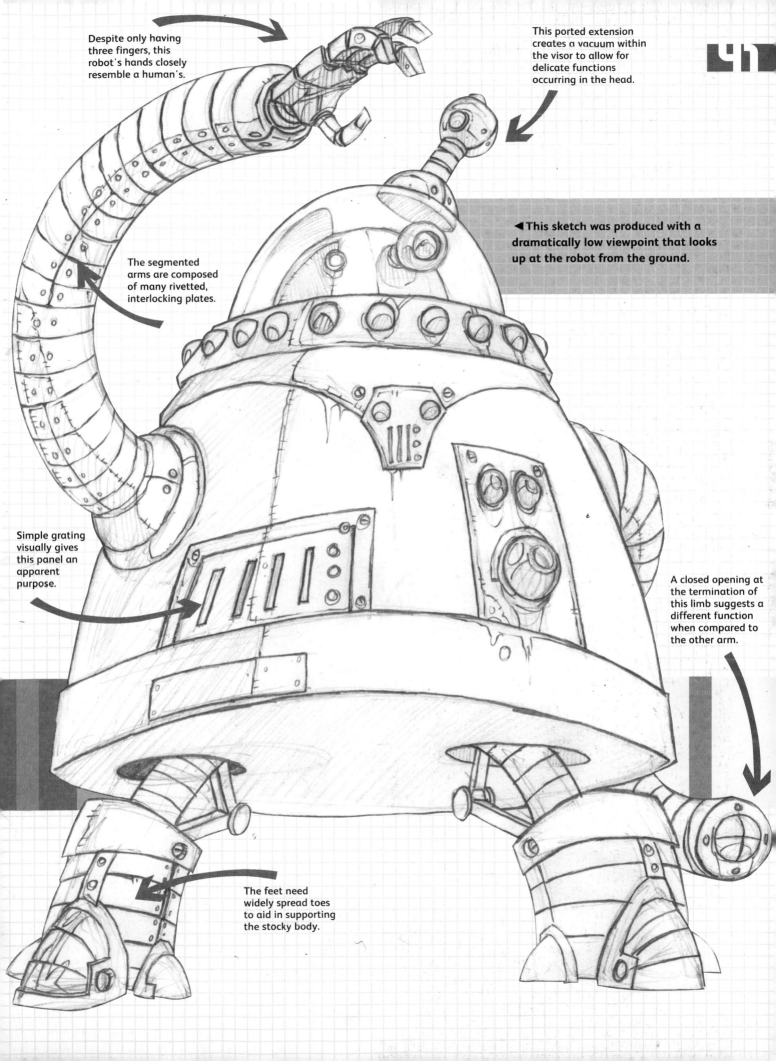

Despite only having three fingers, this robot's hands closely resemble a human's.

This ported extension creates a vacuum within the visor to allow for delicate functions occurring in the head.

◄ This sketch was produced with a dramatically low viewpoint that looks up at the robot from the ground.

The segmented arms are composed of many rivetted, interlocking plates.

Simple grating visually gives this panel an apparent purpose.

A closed opening at the termination of this limb suggests a different function when compared to the other arm.

The feet need widely spread toes to aid in supporting the stocky body.

42 EMULE

MAIL-DELIVERY BOT

Basic shapes

1 The Emule was introduced in 2023 as an efficient means of coping with the colossal amount of physical mail that was created once everyone shopped solely online. Prepacked at the sorting office, the capsule is secured and sealed, giving complete protection to its contents.

The angle and bend of the arm add to the impression of the robot being depicted in midstride.

The head counterbalances the main cylinder.

The feet are flat and sturdy to provide support.

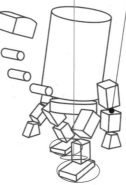
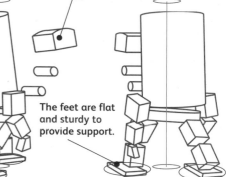

Outlining

2 The arms are almost superfluous, only occasionally used for self-righting and for opening awkward gates. It is common to see models without the arms fitted at all.

Streaming DGPS coordinates ensures efficient and accurate navigation.

Shading

3 Try to emphasize the shape of the object with crosshatching to make it appear more solid and to give an indication of the light source.

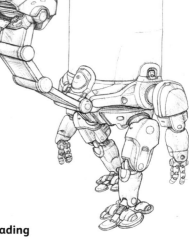

The "beak" is actually a prehensile (gripping) digit for opening letterboxes.

Rendering

4 The shape is basically a cylinder on legs. To get a realistic sense of motion and posture remember that this robot basically functions as a humanoid bipedal with unique weight distribution.

The Emule can walk comfortably on tiptoe and on any uneven surface.

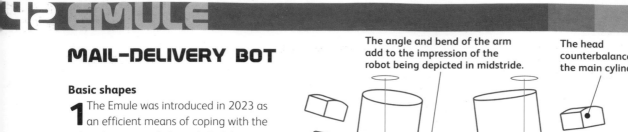

ADIUVO

PERSONAL ASSISTANT BOT

Basic shapes

1 Adiuvo is a human-friendly domestic personal-assistant robot, an advanced evolution of early twenty-first-century robot toys that began the rise of the robots. This robot has a very simplified human form. The joints are all ball or cylinder joints, depending on how the relevant body parts are required to move.

Cylindrical Head.

Torso consists of three main volumes, representing ribcage, stomach, and pelvis.

Simplify hands and feet.

Outlining

2 Quickly sketch the basic forms with a light gray marker. Once you're happy with the pose and proportions, you can go back over the marker with a pen or pencil to tighten up the details.

Concentrate detailing on areas of interest, such as the face, hands, and joints.

Use color and texture to indicate different construction materials dependent on the part's function.

Use text-warping tools in your painting program to create logos or labels that appear to follow the plane of the surface on which it's imprinted (see Decals and Logos p.20).

Shading

3 Use the Airbrush or Paintbrush tool in your digital painting program (e.g. Photoshop or Painter) to establish volumes quickly, keeping in mind a constant light source and light direction. This can be done on a separate layer in black and white for now—you can colorize the layer in the next step.

Rendering

4 Clean up the simple shading from the previous step. You can add color at this stage (a subtle, desaturated color is preferable, so that "hot" spots such as eyes and logos stand out more). Go back with a solid brush to render details and establish clear edges in the painting.

44 MONKEYBOT

ROBOTIC ZOO

Basic shapes

1 One of the more popular designs used in robotic gladiatorial fights, the Monkeybot uses its basic humanoid structure to adapt efficiently in differing combat situations. Its design also allows human pilots to take control of the robot directly if needed.

Basic shapes are cylinders, spheres, and ovals.

Two indented circular plates are aligned on a curve that follows that of the torso.

Arms depicted stock straight, being used as extra support.

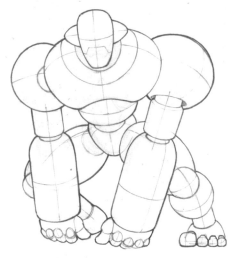

Outlining

2 Primarily spherical, the Monkeybot's curved surfaces are kept as a consistent theme throughout the design. A contrast is created with angular segmentation in some parts.

Add highlights and scratch marks to the edges of the robot's panels to enhance the mechanical look and for a feeling of wear and tear.

Add yellow and blue overlays.

Shading

3 Paint in the robot's basic shadows. To enhance the dynamism, two light sources were used for this robot.

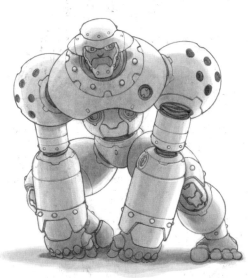

Rendering

4 Lay down the basic colors; red and green are used for the basic undertone colors on this robot because they are complementary and will create an attractive effect together.

PAHS 58

SUPPORT FIGHTER

Basic shapes

1 This robot has a profile that leans forward due to the extended cockpit. The gun arms and missile bays are situated further to the rear, which aids balance. The triple-jointed legs help it move smoothly over rough terrain, allowing for both rural and urban applications.

This axis, along with the secondary axis further down the arm, allows for a full range of movement.

This top part of the arm is larger than the rest of the limb because it houses the missile bays.

Elongated toes help the robot stay balanced when firing its weapons.

Outlining

2 Keep your sketch rough and light. This will help you work quickly and make it easier to erase the pencil once you have inked the design.

Tighten up the details as you ink. Evaluate the overall look of the robot as you go. Eliminate some of the smaller details if you think the robot is looking too cluttered.

Be careful how you use highlights. Too many highlights will make the PAHS 58 appear wet or fake.

This decal follows the same slant that can be seen in the contour lines defining this part's surface plane.

Shading

3 Create a consistent hierarchy of highlights and shadows. The black shadows seen inside gun barrels and joints can be laid in first as a reference point for other shades.

Pick a light source and stick with it. Consistent shadows add a feeling of weight and depth.

Rendering

4 Avoid using a multitude of colors in your design. A main scheme of two colors with one or two accent colors works best.

46 PROTOTYPE HOVER ROBOT

ROBOT WARS

Basic shapes

1 One of the newest entrants to the robotic gladiator arena, this robot has performed admirably even in the prototype phase. Its relatively simple structure allows it to absorb huge amounts of damage and still maintain prime functions.

Pointy shapes imply a very aggressive attitude.

The large spherical head functions as a focal point to all the other parts of the robot.

The base's cylinders are laid parallel to each other to imply the main direction of locomotion.

Outlining

2 The robot's pose and overall composition tell its story. Use expressive shapes and body postures. This robot takes an aggressive pose and appears to be preparing for imminent engagement with an enemy.

Heavy shadow implies that the robot is floating.

Shading

3 Lay in some dramatic full blacks to act as a touch point for all the other shading.

It's easy to imitate existing ideas, but the fun of drawing robots is that they can be in any shape and color.

Bright colors are appropriate to the confrontational attitude of the robot.

Rendering

4 Imply a variety of textures in your design to show off all the materials used. Shiny areas will read like chrome, glass, and glossy plastic. Dull or matt areas will convey a feeling of metal, cloth, and painted surfaces.

FATTYBOT

ROBOTIC CARHOP

Basic shapes

1 The Fattybot is the carhop at a chain of fly-in diners run by an entrepreneur who acquired his fortune in the dog food industry. Its basketball-shaped construction suggests fast food rather than sporting health.

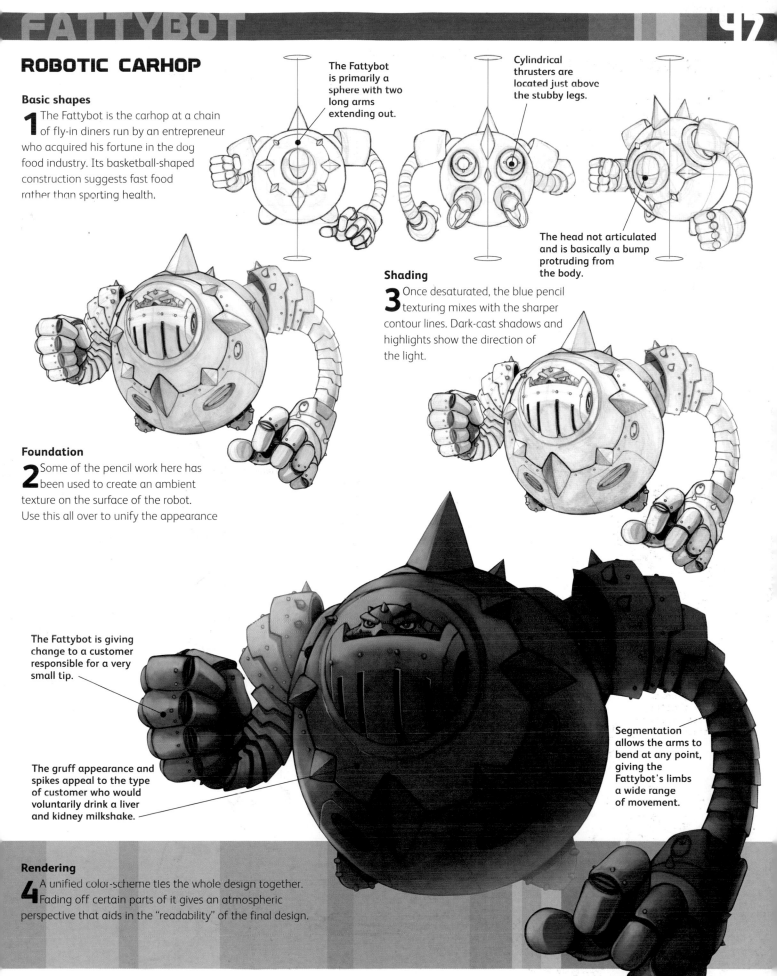

The Fattybot is primarily a sphere with two long arms extending out.

Cylindrical thrusters are located just above the stubby legs.

The head not articulated and is basically a bump protruding from the body.

Shading

3 Once desaturated, the blue pencil texturing mixes with the sharper contour lines. Dark-cast shadows and highlights show the direction of the light.

Foundation

2 Some of the pencil work here has been used to create an ambient texture on the surface of the robot. Use this all over to unify the appearance

The Fattybot is giving change to a customer responsible for a very small tip.

The gruff appearance and spikes appeal to the type of customer who would voluntarily drink a liver and kidney milkshake.

Segmentation allows the arms to bend at any point, giving the Fattybot's limbs a wide range of movement.

Rendering

4 A unified color-scheme ties the whole design together. Fading off certain parts of it gives an atmospheric perspective that aids in the "readability" of the final design.

48 MANTA

HOVERING DROID

Basic shapes

1 This hovering maritime surveillance bot has a simple, flatfishlike structure. In the next step you would just need to refine and vary the shapes in order to get more complex surfaces and curves.

The wings complete a full shape that's been broken in two places by the landing gear.

The core parts of the robot form a center section differentiated from the wings.

When angled flat, these parts will complete the full wing shape.

Shading

3 Shading was done digitally in Photoshop. After choosing the direction of light, take a normal round brush, make sure to control the opacity with your graphic pad, and quickly paint in the main shadow and light areas. Clean up the pencil outlining, too.

Outlining

2 Outlining was done in 2B pencil to give energy and a textured grain to the lines. Think about mechanical joints and how the different parts are connected. Get the perspective right before moving on.

Protrusions are kept horizontal and pointing in the same direction as the intended path of flight.

Panels lie flush due to aerodynamic considerations.

A reinforced structural line runs straight through the robot, passing through the landing gear joints.

The communications array rotates and retracts into the hull of the robot during flight.

Rendering

4 Use metallic colors and add texture layers to achieve more details. Don't use too many colors, though. Push the values in order to gain contrast and create heavily lit areas that will bring out the Manta's shiny surface. Add decals to finish.

MILITARY INCURSION ROBOT

COMBAT SPECIALIST

Basic shapes

1 Fundamentally humanoid in shape, this intelligent foot soldier shows many signs of its close physical-combat role. Joints and limb segments are human-based, and these should be familiar to an artist when working on this design.

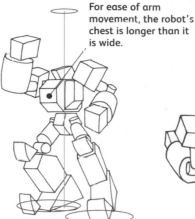

For ease of arm movement, the robot's chest is longer than it is wide.

The pelvis is quite small. It really only functions as a joint and houses hardly any other internals.

Every angle shows how the bulky arms dominate the design and posture.

Outlining

2 There are many techniques you can use to make an initial sketch. Try alternating between pencil and light gray markers. The lines will be easy to remove when you scan your inked drawing.

The head canopy closely protects the robot's optical sensors during combat.

Shading

3 Be sure to use a variety of line weights when inking your final drawing. This helps add interest and gives more volume to your shapes. Use a set of different-sized pens to sequentially build up your line weight.

Two support cannons are fitted in the chest and, being intended for point-blank use, have a limited range of fire.

Small details like smoke can add visual excitement.

Rendering

4 Beveled edges tend to pick up more light and give you a good opportunity to add some highlights. The joints are perfect places to add rust and grime. Tint internal lines to make them seem enclosed.

50 PREDATOR

SPY HUNTER

Basic shapes

1 The simple underlying shapes of the Predator belie its hidden complexities as an infiltrator behind enemy lines.

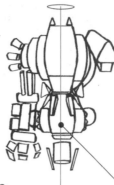

The pelvic base pivots very little, leaving the robot's posture stock straight.

The arm is the only element of the robot that has a wide range of movement.

The rear of the gun extends further back than the muzzle protrudes (for aiming clearance reasons).

Outlining

2 Use a 20% gray-shade marker to sketch the robot and all the relevant details. Outline with a 0.1 fineliner. To give more emphasis to the shapes, accentuate certain lines and make them thicker with a 0.5 fineliner.

Add details so that each feature of the robot looks functional and believable.

Text decals such as numbers will give additional authenticity to the robot.

Shading

3 Some elements of this robot are illuminated, which can create a slightly strange impression at the shading stage.

Rendering

4 The slightest evidence of pitting, wear, and discoloration add an invaluable air of believability and solidity to the robot design.

The exhaust parts show far more wear than the other sections of the robot, and slight evidence of emissions tells the viewer more about their function.

WHEEL-E

GARBAGE DISPOSAL

Basic shapes

1 The Wheel-E bot resembles a trash can on wheels. It is used primarily in a janitorial role on factory farms. Trundling along on its sturdy tractor wheels, it shovels food unit by-products into its hinged waste disposal container which also doubles as a garborator.

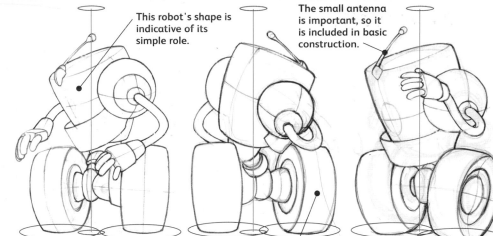

This robot's shape is indicative of its simple role.

The small antenna is important, so it is included in basic construction.

These large inflated tires will later be treaded.

Outlining

2 Simple cylinder shapes are used initially, as the core of the robot is intended to resemble a basic waste receptacle.

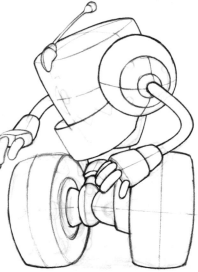

This antenna swivels forward and is actually a highly sophisticated olfactory sensory device.

Shading

3 All the extra details are developed at this point and laid on the basic structural form of the loose-line stage.

The Wheel-E bot can become so caked in detritus during work that these warning lights spin and flash to warn farm workers when the clumsy robot draws near.

Rendering

4 With the exception of warning lights, this robot has a simple, utilitarian paint job. The Wheel-E bot's designers weren't too concerned with decorative aesthetics as it won't win any beauty awards after a couple of days working on the farm!

NATURAL WONDER

Basic shapes

1 The company Chanzon Industries introduced this crab-shaped prototype in 2012. Its mission covers a full range of national park surveillance from the poles to the equator, helping to predict the behaviors of migrating creatures as the ice caps melt.

The jointing of the legs is based on a sphere-joint system. Wheels are used for long rides on flatlands.

The geometry of this robot is fairly simple. With simple blocks you can understand how the elements are connected.

The geometric construction shows the general shape and the balance between legs and main body.

Blocking in

2 Now that you understand the skeleton, it's easy to block in the shapes and start to outline. If you don't feel secure, go for the values with gray tones. You can paint over the shaded image later using new layers.

Shading

3 Block out general shapes with monochromatic tones, then erase this shape and start to define the design of your robot.

Greenbot is made of composite recycled plastics on an aluminum frame. All the components for observation, navigation, communication, and analysis are placed inside the body.

Rendering

4 Because digital images can look too neat, think about using textures and customized brushes in Photoshop. Add some textures over your actual painting using Overlay, Soft Light, or Color Dodge. To finalize your image, cast a shadow on the ground surface.

This robot actually walks on its knuckles, using its extended digits for climbing and environmental interaction.

SENTINEL

HIGH-RISK ROBOT

Basic shapes

1 The robot is designed to perform high-risk operations in harsh terrain. It uses contemporary technology, but the look of the robot is relatively simple, primative, and clumsy.

The body and legs of this robot are bilaterally symmetrical to the axis of balance.

This head portion will appear to be split in the more developed phase but will still conform to this basic shape.

The legs connect to this central section; the head and lower container branch off from this part as well.

Outlining

2 Enlarge the picture to the desired final resolution. All the lines will be a little blurry and pixelated, so it's necessary to make the drawing clearer. Enlarge the picture on the monitor to play with the details.

Add dirt or rust to make the Sentinel look used.

Your various color tones and shadows will create a real feeling of the depth in the picture.

Shading

3 Light source affects the whole look of the picture. The best way to add shadows and color in Photoshop is to make a duplicate layer of the line drawing and work on the layer beneath.

Rendering

4 This robot has a military function, so drab olive greens are appropriate. However, it's easy to change the color anytime— unlike the direction of light. Sticking with your choice of light source is crucial at the finishing stage.

Keep in mind that both shadows and colors behave differently on flat or round surfaces.

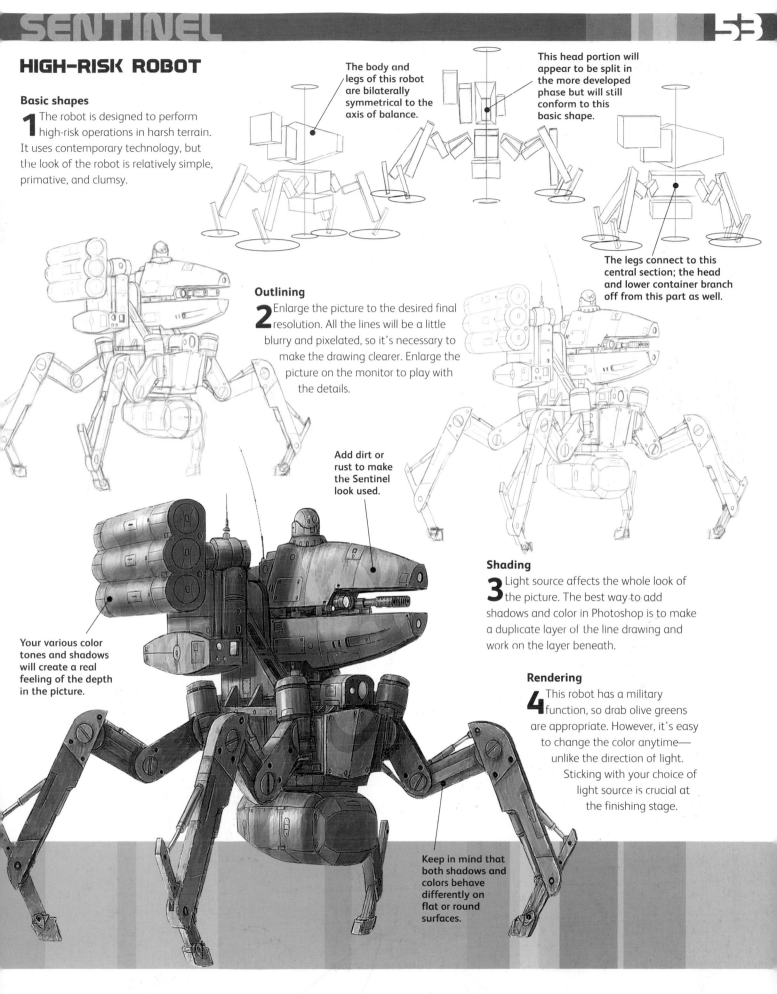

DOGWALKER DELUX

Basic shapes

1 The initial basic shapes of boxes, triangles, and circles are still apparent in the finished design. A third wheel is included on a flexible limb, adding balance, and the simplified pincer hands further enhance the nonhuman shape.

Simple cylinder shapes are easy to draw.

Squashed squares define squat stature.

Triangles add strength to an image.

Each section of the body can turn independently of the others.

Freehand approach

2 All the underlying shapes of this domestic friend are drawn freehand. This makes the robot seem well-used and friendly.

Crosshatching

3 Use crosshatching and shading to identify which direction the light is coming from. By giving the nuts and bolts a dark outline, the robot gets a very functional, industrial, worn look.

Contains recordings of the dog owner's voice.

Multipurpose hands cope with multiple dog leashes simultaneously.

Dodi was discontinued because of dog leash tangling concerns.

Color palette

4 A color-scheme with brightly contrasting colors reveals the Dodi as the domestic servant he is. Any semblance of his industrial past is wiped away by these cheery tones.

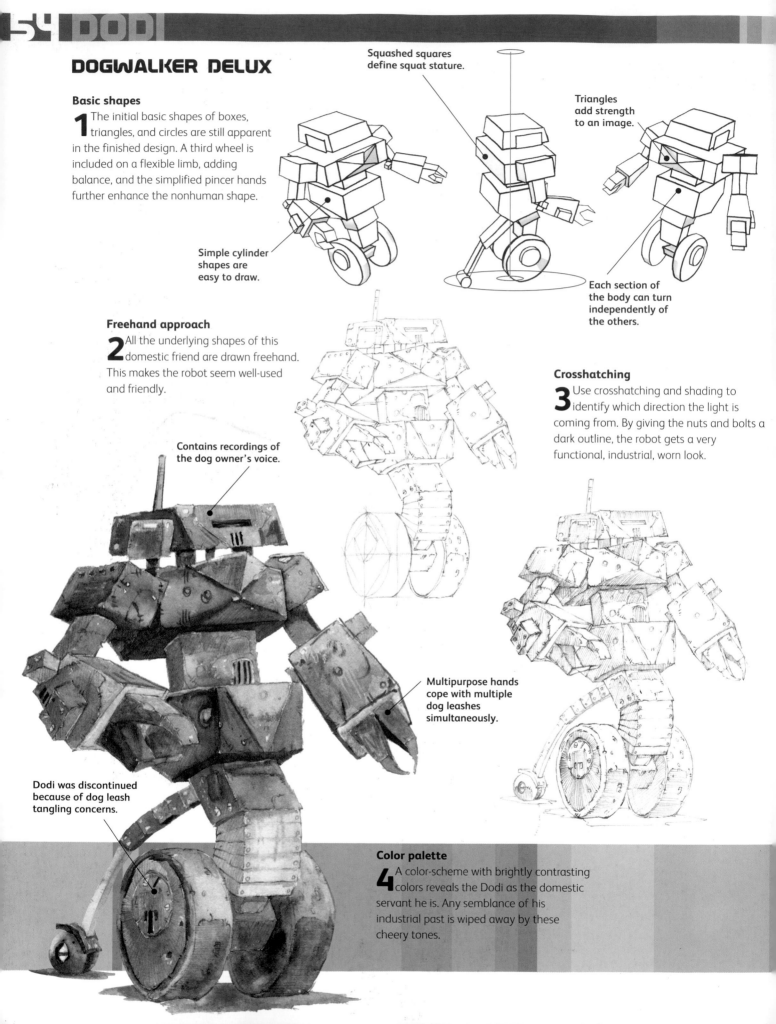

PROSTHETIC COMMANDO

Basic shapes

1 Some highly decorated soldiers of the Interspace Army who've suffered debilitating mutilation can awaken to find themselves interred in robotic shells. The robot's stance is wide, stable, and stiff, and its arms are elongated to compensate for limited agility. The profile is brutish and hunched.

The armored curve of the upper body is distinctive.

The curve does not continue to the back.

Arms are held out somewhat.

Outlining

2 All of the armor is bulbous and curved so keep the lines sinuous and flowing. Don't worry about shading. Your focus at this stage should be form and texture.

Developmental reactive armor shatters outward on ballistic impacts.

The face plate opens to reveal more precise optical equipment for long-range detection and engagement.

Shading

3 Some of the internals are in danger of getting visually muddied at this stage. Differentiate the organic from the metal by using separate hues. Keep the brain's shading delicate.

Rendering

4 Used in a more public and ceremonial role, this robot can have an eye-catching and purposefully decorative color scheme. The distinctive red star and numbering decals have been applied to complete the theme (see Decals and Logos, p. 20).

Fashioned to put an end to peace, these robots have been applied to the lamentable cause of perpetual destruction and horror: Asimov's first law of robotics didn't even get a second thought. **Military robots** have a distinct attitude and appearance, their purpose clearly evident. **Some may have** thick, defensive armor, while others may have only thin shields to allow for ease of movement. **All, however, will** be blessed with aggressive tendencies.

Developing ideas
One of the primary things to consider on this type of robot is its weapons. Military robots will often have integral weaponry; changing them may affect entire limbs, or even the whole robot itself.

▼ The gun is primed, arm steady, ready to fire.

▲ The bladed back extension is useful for felling enemies who attack from behind.

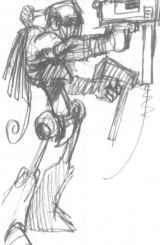

► This military robot's pose is determined.

MILITARY ROBOTS

In this version, the arm is thick and powerful for close combat.

In this rear shot, the major back protrusion has been left off.

ON THE WARPATH

From all angles
Draw the figure from several angles while you fine-tune its design.

In this side view, tank treads replace the legs.

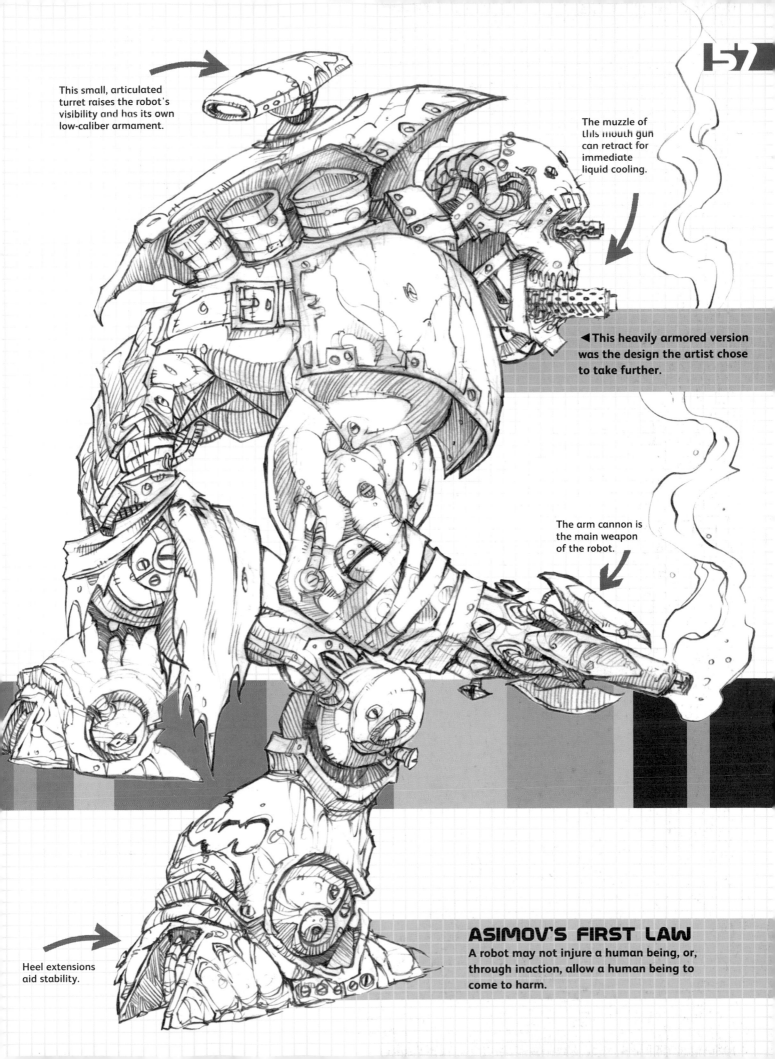

This small, articulated turret raises the robot's visibility and has its own low-caliber armament.

The muzzle of this mouth gun can retract for immediate liquid cooling.

◄ This heavily armored version was the design the artist chose to take further.

The arm cannon is the main weapon of the robot.

Heel extensions aid stability.

ASIMOV'S FIRST LAW
A robot may not injure a human being, or, through inaction, allow a human being to come to harm.

58 BRASS LION

Designed by engineer Isambard Kingdom Brunel himself, the Brass Lion was a marvel even at the height of the British Industrial Revolution. **The robot achieved** international fame when a single Brass Lion saved the charge of the Light Brigade in the Crimean War by smashing into the Czarist artillery position. **It was eventually** felled, but not before bursting open and spraying its attackers with boiling water.

SEE ALSO
Drawing and Research, p.10
Rendering Materials p.18
Developing Your Ideas, p.26

Series of adjustable and interchangeable telescope lenses.

This narrow canon is intended as a one-shot, disposable weapon that splits open and is discarded after firing.

Primary coal furnace.

Forward wheel-arms used as base when the robot settles into firing posture.

Enlarged six-shot revolver affixed to saber arm.

Adaptation of a cavalry saber for slicing at foot soldiers from an elevated position.

Steam-age robot
Being steam powered, this robot needs some recognizable signs of its power source—such as this wooden-handled lever, and gauges for assessing internal pressures.

Ornate and functional
There are two distinct design styles in this robot: the ornate and decorative armor and gilding, and the more functional-looking steamers and boilers. The industrial parts function more as a structural core, with the more ornate elements acting as an armored, decorative shell.

Victorian inspirations

Surprisingly, a lot of the design is as much influenced by Victorian British furniture as it is by steam engines. When dealing with such elaborate ornamentation, even greater care has to be taken to allow the limbs and moving parts to function freely of each other.

Slim but strong

1 The key connection point in this design is where the chest meets the belly, and it must be slim for maneuverability but still remain strong looking.

Frontal view

2 The main shape of the torso and head almost converge into one large shape in the front view.

Axis of balance

3 The whole body profile curves to allow the axis of balance to run through the middle. (Assume the central steam engine is heavy enough to prevent the cannon from overbalancing the robot.)

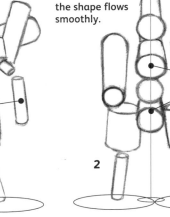

Note how the saber arm bends outward to offer clearance from the thick thighs.

None of the parts are squared off in their relation to each other, so the shape flows smoothly.

Both the pelvic cylinder and the chest cylinder are angled almost parallel to each other.

All the cogs, wheels, and gears must be thought through and defined completely at this stage of the artwork.

▼ Distinct shading

Distinct and strong shading is necessary on the dominant cylinders in the design. Complement areas of high detail with stark areas of shading.

The splash of intense red in the plumage is an ostentatious "period" touch to the design.

▲ Plume detailing

Remember to use some loose pencil lines to add the fibers of the plume and to create some denting and roughness to the thigh's brass plating.

Darken the internal workings seen in the chinks of the thigh armor.

▲ Metallic hues

Many differing metallic hues are used here, varying through grays, blues, greens, yellows, and reds. Their shine and texture are what indicate their metallic construction, and not their color.

60 PANZERFLUCH AUSF G

SEE ALSO

Rendering Materials, **p.18**
Joints and Movement, **p.30**
Decals and Logos, **p.20**

The Third Reich's answer to the British MBW (Main Battlefield Weapon) is fully committed to an antiarmor role. **Loud and lumbering,** this monster crashes through the undergrowth, its presence instilling dread in enemy tank crews. **Eventually its lack of speed** and maneuverability, however, made it much too vulnerable to antitank infantry.

Exhaust pipes from engine.

Hatch leads to small compartment for a single surveillance and communications crewman.

Standard-tank-issue entrenching tools and tarpaulin.

Clamp used as self- righter and to carry extra loads of equipment.

Cannon terminates in a tightened muzzle-break that employs a "Gerlich" antirecoil design.

Details and accessories
Hatch details and conventional tank accessories add to the richness of the design. However, ensure that these details are carefully selected and add to the overall impression of the robot without cluttering or muddling its profile.

Presence and strength
Far larger than the other MBWs, the Panzerfluch design needs to convey its great size and presence. Many elements have been cannibalized from genuine German tanks of the period, such as the distinctive exhausts and paint job.

Armored guncarrier

Primarily rectangular, this robot has a limited range of limb movement. It's still fundamentally a tank, no matter how anthropomorphic the design becomes, which means the entire design should service the most important component: the gun. Elements such as the distinctive grid armor-plating are repeated in sections across the front part of the robot.

The gun is positioned parallel to the torso during movement.

The axis of balance must still lie evenly between the legs during straight movements.

The head is set far forward on the torso, creating a hunched effect.

Intent pose

1 Another good example of a robot moving with a tipped axis of balance (in the direction of its movement).

Low-slung power

2 Note how low the knees are, shortening the shins dramatically.

Lean and mean

3 The lower torso and pelvis are quite thin and contain minimal internal parts.

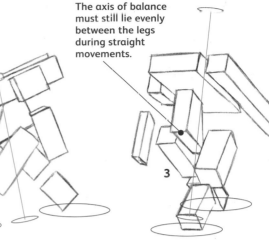

▼ Details and lighting

Areas of high detail will often begin to appear darker than the rest of the robot (when you actually may want them to be lighter or shinier). Don't worry about this, as it will be addressed in later stages.

◄ Shining joints

Note how certain cylindrical joints are receiving a slightly different shading treatment due to being polished metal (as opposed to roughened armor-plating).

Notice how the armor's grid pattern becomes far less dominant in the shaded version.

► Green and gray

Much of the gray metal in this robot is actually quite green; it only appears desaturated because of its proximity to the strong yellows of the paint job.

The decals are simply loosely painted additive color (directly applied, not glazed).

62 MEDVED PRODUCTION TYPE I

Churned out of Soviet factories with the initial intent of recapturing Stalingrad, the Medveds tore a path through the German Panzer divisions in the great armored conflicts at Kursk, in July 1943. **A wartime expedient,** the Medved was just as temperamental as previous generations of battlefield robots but still shone when pitted against German mechanized troops.

SEE ALSO

Rendering materials, **p.18**
Bits and Widgets, **p.32**
Attachments and Embellishments, **p.34**

194mm field gun fed with 80kg high-explosive shells.

Plated shielding to protect loading crews from shrapnel.

Elaborate muzzle-break helps minimize recoil (which would otherwise shake the robot apart).

Real-life inspiration
As well as the Soviet tank decals, details like the wires that connect the headlights to a hidden battery are adapted from real 1940s references, gleaned from World War II history books.

Russian bear
The Medved could be described as a robotic bear carrying an artillery piece on its back. Animalistic touches have been worked into the design, giving the head something of a snout, and using fixtures such as the claws, which make its feet resemble paws.

Snowclaws clamp down during firing to prevent the robot from shifting with recoil.

Feet fitted with ski undercarriage for use in snowy conditions.

Powerful ally

The design is of a quadrupedal robot whose function is to trudge around and fire the huge gun mounted on its back. Keep the front heavily armored and bare of overly exposed joints and details (this is the most likely target in battle). The back legs have been given a slight increase in size, complexity, and strength because they have to absorb the gun's recoil as well as carry a heavier load than the front of the robot.

Weight distribution

1 A huge amount of weight is distributed in the rear of the robot, and the axis of balance is placed quite close to the rear.

Boxlike body

2 The body of this robot is quite squared off and could even have been adapted from a conventional tank.

The bear's muzzle

3 The cylinder of the gun barrel tapers toward the end until it arrives at the muzzle-break.

Note the distinct shape and posture difference apparent in the fore and aft legs.

Extended reach is more important in this design. Like many World War II robots, the entire structure is almost completely rectangular.

The forward-tilting head makes it look like it's glaring under its brow.

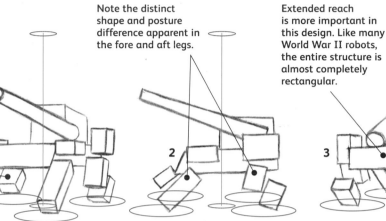

1 2 3

▼ Angles and curves

The linework is composed from many hard angles and tight curves, so keep everything tight and be careful as you draw it. That said, slight flaws, such as dents and scuffmarks, are good things to include.

The rivets and small details almost clutter the piece at this stage, so they'll need to be knocked back in later work.

◄ Strong shading

Use very bold planar shading. With so much going on in the design, shading is key to visually separating the legs from the body.

Within the planar shading, apply some metallic texturing on the armor (separate it into two stages).

Decals such as the intensely red star can really attract the eye, so be careful where you place it.

► A Russian winter

An "arctic" paint job has been applied here (except of course to the actual gun barrel), and the entire robot has been lightened, but as the paint job has been additively glazed, the underlying shading is fundamentally unchanged.

64 TAS-21 NEEDLE

The Needle is an evolution of the guided cruise missile. Once it has been deployed behind enemy lines by sea or by H.A.L.O airdrop, the Needle advances on all fours to an optimal vantage point, whose coordinates are continuously fed to the robot by satellite tracking. As soon as it has arrived at its destination the Needle becomes dormant, concealing itself until the **designated target** comes within range, at which point the cruise missile launches and the exoskeleton detonates to keep the technology out of enemy hands.

SEE ALSO

Drawing and Research, **p.10**
Artistic Rendering, **p.16**
Rendering Materials, **p.18**

Initial targeting sensor paints the target with a marker, and then feeds this information to the cruise missile's internal guidance system before firing.

Small gas canisters on the side emit a smokescreen that gives the Needle enough time to fire and self-destruct in the event of its discovery.

Forefeet can function as opposable digits for easy access to high vantage points, even allowing the Needle to climb trees and buildings.

Highly accommodating base and frame allow new cruise missiles to be retrofitted for use in the Needle.

Function dictates form
At this point the robotic form is little more than a support frame for the cruise missile. Simplifying the robotic parts in this area helps the viewer understand that the missile and robot are two separate entities.

Do not worry too much about textural aspects at this point; the difference between the robot and the missile can be made more apparent at the later stages.

▼ Plating and linework
The slightly curved plating of the articulated, robotic sections offers an attractive contrast to the more simplistic and purposeful linework of the missile.

Use contrast here

Your design should make obvious the fact that the robot is nothing more than a sophisticated delivery system for its payload. The missile is the core and the robot is built around it—not obscuring it, but rather drawing greater attention to the missile through contrast.

Communications array extends from split rear bay.

The weapon is key

The robot's core is the cylindrical missile, which makes an excellent base to work with at this stage. Being a quadruped, the robot gives the artist far greater scope for where to place its axis of balance.

Weight dispersal

1 Note that the robot is placing more weight on its rear legs than on its forefeet.

Leg structures

2 The structure and jointing of the legs are virtually identical at the rear and to the fore, but the proportions are different.

Firing function

3 In reality, the rear end would be an open channel with no obstructions (for recoilless firing of the missile).

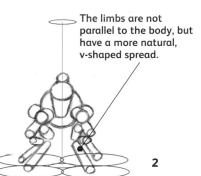

The missile is tilted slightly upward (for a degree of clearance when firing).

1

The limbs are not parallel to the body, but have a more natural, v-shaped spread.

2

Note how much longer the back legs are than the forelegs (to enable frog-like leaping).

3

Keep the shading smooth—the missile should appear aerodynamic.

▲ A distinct form

Again, tighten up on the shading of the missile. A distinct, cylindrical form is key to making the design work.

▼ Emphasis through paint

To emphasize the separation of robotic frame and cruise missile, apply different paint. A difference in the paintworks' reflectiveness indicates that the missile is of a different material from the robot's plating.

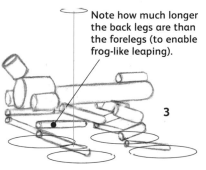

Even though the robotic parts are a silvery white, include a touch of ambient color.

66 M24 HAUSEN

Brought late into the war by the Americans and first deployed from the landing craft on the Normandy beaches, this robot benefited from a design already tested by years of application in war. Originally intended to fulfill an **antiaircraft role**, the Hausen was found to be an invaluable aid in the urban combat taking place on the long road to Berlin. Its four guns proved to be **a boon to Allied troops**, with the ability to lay down a withering curtain of lead to tear through sniper roosts.

SEE ALSO

Drawing and Research, **p.10**
Rendering Materials, **p.18**
Joints and Movement, **p.30**

Set of four 35mm flak cannons.

Rotating turret.

Secondary sighting system aimed at the sky for an antiaircraft role.

Plated skirt protects shoulder joints and allows for quick servicing.

Enemy in sight
The head is fitted with two main sighting systems: forward and upward. The forward sight is more complex and telescopic to better locate well-concealed sniper positions.

City deployment
A mobile AA (antiaircraft) vehicle is the basis of this robot, and the rest of the design has been developed from that starting point. Since it's used in urban situations, enlarged forearms have been added for interaction with its environment.

Extremely large forearms used for added stability and for breaching walls and barricades in urban environments.

Tanks for the memory

Angular and boxy, this robot has to look like an extension of an existing World War II tank. Small elements and basic shapes have been lifted from real tank designs for use in the robot. Again, symmetry is key, and a vehicular feeling should be maintained in this large robot.

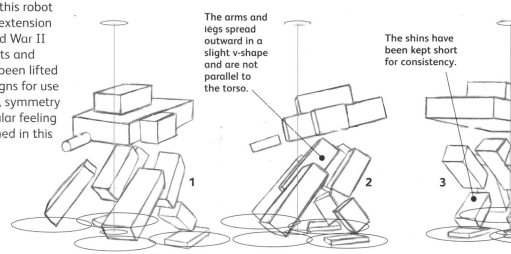

The arms and legs spread outward in a slight v-shape and are not parallel to the torso.

The shins have been kept short for consistency.

Axis power

1 The axis of balance is shifted forward as the robot is resting some of its weight on its arms.

Torso balance

2 The upper torso extends widely outward but is still balanced on its lower torso.

Center of gravity

3 The legs are constantly bowed to bring the center of gravity lower for improved stability.

Lay down more line than you need— you can always erase it on the computer if you've overdone it.

▼ Plane changes

Every time a change of plane occurs, the shade should differ to indicate it. Use lighter highlights around the edges of separate plates.

Lay the texture in strong for these types of heavily weathered robots.

▼ Camouflage style

A sandy paint job has been applied here to camouflage the robot in areas of dusty brick ruins.

▲ Tight linework

Keep the linework tight and geometric, but within that constraint remember that a degree of weathering and ruggedness should also play a part.

The decals are kept uniformly white to contrast with the darker paint job.

68 ORGANIC GENERAL-USE SOLDIER

The OGUS has become an **indispensable asset** to the military forces of all Category One nations. A hybrid of mechanical parts and specially tailored, **silicone-based, organic components**, the robots of the OGUS series have attained a battlefield strength superior to anything a conventional human soldier could muster. Although expensive to build, maintenance is simple: the OGUS series is **primarily self-healing**. All models are meat-eaters powered by methane, the by-product of processing organic matter.

Long, thin, highly flexible neck allows for excellent visibility.

Mortar for bunker penetration.

SEE ALSO
Life Is Your Palette, **p.21**
Attachments and Embellishments, **p.34**
Military Attachments, **p.36**

Humanlike limbs facilitate the use of enemy weaponry when deployed behind enemy lines.

Compact profile presents the smallest possible target for enemy fire.

Modular, load-bearing packs for equipment.

Worming into its consciousness
The staring face is serpentine, annelidic—segmented and wormlike—and slightly disturbing in appearance. The robot's sensor array can detect numerous substances, trace elements, or signs of life, such as the frightened breath of a human soldier, vehicle exhaust, and even the warmth generated by bacteria, the possible evidence of a human presence.

Insect meets Man
Sinewy and bowed, the OGUS is primarily a predator. The robot is intended for stealthy operations and is cased accordingly in dull, matte, ballistic plastics that deflect sensors. Its mix of insectlike carapace and humanoid muscle-forms is offset by hard-edged additions, such as its equipment compartments. Think of the OGUS as essentially an insectile humanoid that functions in a similar way to a human soldier.

Classical pose

Note that the OGUS depicted is in a "contrapposto," or counterpoise position, meaning he is standing in a relaxed, classical stance with his weight on one leg. Statues in museums are great references for your robots. Of course, these classical applications are adapted and modified for the OGUS's unique anatomical structure.

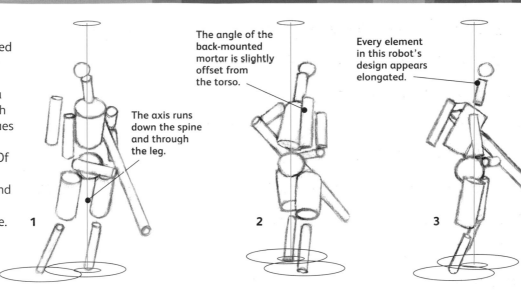

The axis runs down the spine and through the leg.

1

The angle of the back-mounted mortar is slightly offset from the torso.

2

Every element in this robot's design appears elongated.

3

Balance

1 Note how different parts balance themselves around the axis. The mortar serves to compensate for the long rifle.

Sum of its parts

2 Though this illustration represents the overall structure, remember that the individual parts curve significantly.

Keeping a low profile

3 The robot slouches to reduce its profile.

▼ Mixing it up

This robot is a mixture of design aesthetics, so remember to intermingle the organic curves among the angular elements. The weaponry stands out boldly in the linework.

Interconnecting carapace sections weave into and over the muscles.

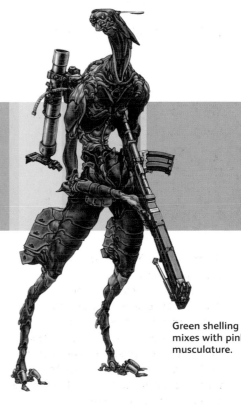

The shading is uniformly heavy but appears darkest on the metals of the gun.

▲ Defining with lines

Dark and serpentine, the shading should conform to the design of the robot. Remember to hold back on the bright highlights in order to maintain the robot's characteristic matte finish.

▼ Organic versus metallic

Emphasize the contrast between the organic and the metallic. Sharp highlights draw attention to the glowing lenses and the glinting metal.

Green shelling mixes with pink musculature.

70 HEPHAESTUS' ANVIL

A walking tank, the Anvil fills a semistationary armor role. Extremely vulnerable to attack helicopters, the Anvil is primarily used for "hold and defend" campaigns and military occupations. **The Anvil is** efficient and intimidating, making it perfect for keeping down insurgencies; however, friendly fire incidents are common, leaving it dreaded by friend and foe alike.

SEE ALSO

Artistic Rendering, **p.16**
Rendering Materials, **p.18**
Attachments and Embellishments, **p.34**

SAM bay for protection from attack helicopters.

Dedicated sighting systems mounted on Vulcan arm.

Modular, reactive armor.

Dome-mounted 11mm machine gun is intended for close-quarter, antipersonnel roles.

Machine of war
The Anvil is a conventional military robot and should, therefore, give the impression of function over form. Rectangular and clunky, the Anvil is intended to soak up small-arms fire. This robot's locomotion is entirely for strategic placement, not evasive maneuvers.

Gun
One of the focal points of the design is the huge Vulcan that the Anvil is armed with. Here we can see where the segmented, fully covered ammunition belt is fed into the chamber. This ammo chain drapes back to the feeding arm and then into the huge drum carried on the robot's back.

Liquid-cooled, 32mm Vulcan used in an antimaterial/antiarmor role.

Rubber treads to reduce damage done to city streets.

Heavily armored drum, containing coils of 32mm belt-fed ammunition.

On solid ground

Even when joint articulation becomes obscured by blocky armoring, it remains important. The Anvil's legs have extended feet resembling those of a horse or goat. Because the robot is very large, expanded feet are essential for stability.

The abdomen and pelvis are less heavily armored to allow for pivotal movement.

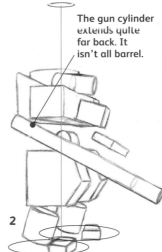

The gun cylinder extends quite far back. It isn't all barrel.

The dorsal shape needs enough room to house two missiles.

Blocklike elements

1 The form is blocky, so much of the feel of the design will be decided in these stages.

Inhuman construction

2 Note the distinctive jointing of the legs and how they differ from those of a human.

Gun placement

3 The gun offers a degree of balance for the huge drum of ammo.

The surface is plated, but not with insectile segments. Keep it to more conventional, tanklike armor.

The shading is two-dimensional and sharp.

▼ Military garb

Drab military colors are the prime scheme for the Anvil. Cooler gunmetal grays offset the warmer body colors. Occasional splashes of warning reds liven up the paint job.

▲ Balancing objectives

Chunky and angular like a tank, this robot is composed of still recognizable primitives. However, curved surfaces will reflect projectiles well and can absorb more punishment. Maintain a balance between the two.

▲ The right tone

Every time a surface plane changes, the tone you use should change accordingly. Again, shinier metals—as on the guns—will reflect light differently from the painted armor.

Spice it up a little if you need to—you want it to look like a military robot but not too realistically drab.

72 MK1: MAIN BATTLE WALKER

First introduced in the European Theater of War in 1943, the MK1 changed the battlefield. **As unreliable and temperamental** as the first tanks in WWI, the MK1 still functioned as an incredibly versatile, all-purpose weapon. This model is fitted with a 105mm Howitzer.

SEE ALSO

Rendering materials, p.18
Attachments and Embellishments, p.34
Military Attachments, p.36

Light machine-gun mounting for a close quarters antipersonnel role.

Hatch placed on rotating head.

Arm joints covered in a jacket to prevent the elements from fouling operation.

Modular clamp hands for multiple weapon-mounting options.

Legs are plagued with problems; an escort always accompanies with spare parts and repair and maintenance engineers.

Gun detail

Designing your own guns is fun, but sometimes using real reference can add a sense of reality to your art. Researching actual examples such as this light machine gun can also help you learn the look and feel of a time period and translate this into your future work.

Conceptualizing the robot

Good reference is invaluable for the robots from this era, and a wealth of military equipment was used by the artist for inspiration. Organic curves had no place in this design, as everything is hard edged and utilitarian. A worn, weathered look was also required, so the illustration shouldn't be too clean.

Constructing the robot

Much of this geometric construction can still be clearly seen in the final design. When making initial sketches, always take balance into account, especially with top-heavy designs like this. Repeat design elements to ensure unity—create a set of rivets, handles, and so on that is reused throughout the design. Remember to space out these details and not clump them together. Proportion is very important when objects that have set sizes are introduced.

Getting the balance right

1 Balance is tricky when the artist is rather unsure of how much different elements may weigh. Here, the main gun is assumed to be heavy.

Look, no hands

3 The arms are attached to the gun at the wrists, so no constructional guides are needed for the hands.

Using oblongs and cylinders for basic construction

2 As long as the main structural shapes are sound, detail can easily be added onto the initial structure.

The torso is rotated to the left from the pelvis.

Ensure that the limbs can move about without bashing into other parts.

Weight of gun pulls the figure forward.

1

2

3

▼ Creating the linework

Using rulers to draw lines tends to create accurate, but stiff, lifeless forms, even on very angular designs like this one, so draw freehand. Lay down lightly sketched shapes using blue Col-Erase pencil. Scan the artwork at a higher resolution, erase the pencil lines, then drop it down to the desired dpi.

Make practice pencil sketches using drawing aids if you're not yet confident drawing freehand.

The rougher the material, the more ambient pencil texturing will aid you later on when rendering.

Color can indicate rust stains and places where the paint has scraped off.

Knocking out the contrast on certain parts, such as this far leg, will separate it from the parts of the robot in the foreground.

▲ Masking and shading

Use the Magic Wand to select the areas you want to work on, and use Dodge and Burn to modify the tone of the drawing. Shading is extremely flat here and care should be taken to keep tones on equal planes the same. Light reflects brightly off the shinier bits of metal (like the handles and barrel).

▲ Coloring

Always adapt the colors to the material. Use the Color Balance adjustment in PhotoShop to add red and yellow to the shadows and midtones of the drawing. Now place a layer over the drawing set to Soft Light. When applied, the color will glaze over the drawing, slightly changing the tone you've already set down.

74 SUBHUNTER

SEE ALSO

Rendering Materials, **p.18**
Developing Your Ideas, **p.26**
Bits and Widgets, **p.32**

In an age when nuclear, biological, and chemical warheads are delivered primarily by submarine, antisub robots are numerous and highly developed. **These robots are** too small for the passive system of a submarine to detect, and they can silently approach these nuclear leviathans to drill explosive charges into their hulls. **Modified Subhunters** are used by pirates to assault and board tankers and merchant ships.

Large central propeller and jets are the primary mode of propulsion.

Variable vents for steering and speed adjustments.

Limbs cling to body during nautical travel to reduce drag.

Drill head with projected, high-explosive charge used for breaching hulls and causing irreparable damage.

Undersea inspirations
The nautical design and component shapes of the robot are derived from a combination of preexisting machines, namely submarines and torpedoes. An element of complexity is also added by using crustacean carapaces as structural influences.

Powerful, superheated talons for anchoring to hulls and tearing open bulkheads.

An amphibious robot
The Subhunter is unique in that it needs to function both in and out of the water. When folded into itself for long distance travel, the Subhunter is intended to resemble a small, deep-sea submarine.

Nautical robots

A believable-looking machine that encompasses hydrodynamic contours is integral to any nautical robot design. Although it is seemingly overbalanced in the torso, much of it is simply a hollow sluice for the propeller and jets.

The talon comes close to, but doesn't actually meet, the ground plane.

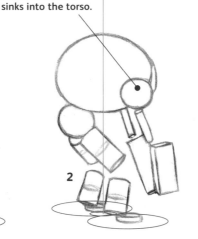

Viewed laterally, the head almost sinks into the torso.

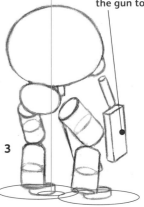

Remember that the drill bit protrudes, so don't make the main body of the gun too long.

1

2

3

Sublike contours

1 Everything in this robot is rounded or cylindrical, apart from sections of the retractable limbs.

Ready to dive

2 Note the permanently bowed posture and the legs that don't lock perfectly straight.

Great ape

3 The posture, proportions, and joints are almost gorilla-like.

▼ Out of its shell

A crustacean is an excellent reference for the kinds of postures and shapes present in the drawing. A hunched, crablike design also creates a predatory impression.

Keep the shapes rounded, and make sure they interlock for an overall smooth profile.

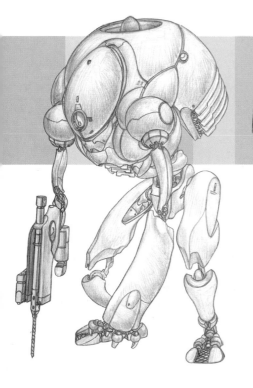

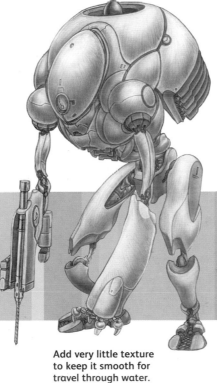

▼ Deep-sea blue

Apply a deep blue to most of the design (remember the role this robot plays). Small, complementary spots of orange add key points of detail.

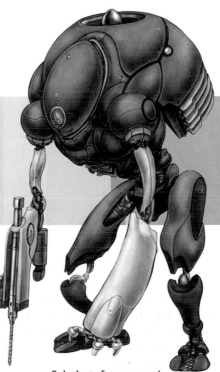

Add very little texture to keep it smooth for travel through water.

▲ Predator

Darkly camouflaged, this robot is designed to approach targets undetected, so a dark, smooth finish is essential.

Splashes of orange and shiny silvers liven up a uniform color-scheme.

Had it not been for the Elektrograd, the Russian stand against the German invasion in World War II would have been doomed in the bleak winter. **A masterpiece of construction** when it was originally created, this eleven-foot tall robot could punch holes in a German Panzer with ease. **Long out of fashion** and out of use, it is now considered a nostalgic museum piece and used only in military parades.

Battlefield machine
The robot is inspired by Russian constructivist propaganda posters as well as by the design of the top war machines of the era. It is rough around the edges but was an inspiring sight in the trenches and the driving snow.

Repelling the invaders
This robot had a heroic and glorious past on the battlefield. The feet are large and long so it can't be knocked over easily, and the legs are attached by means of ball-and-socket joints for ease of movement over the rough terrain.

Early cog-driven processors in the head use color recognition to identify enemies on the battlefield.

SEE ALSO

Working Traditionally, **p.12**
Joints and Movement, **p.30**
Bits and Widgets, **p.32**

Powerful, gyroscopically balanced hands for repelling invaders.

Composite steel and iron superstructure, tempered for resilience to fire, explosives, and chemical agents.

Industrial might

The Elektrograd was cobbled together from industrial parts and battlefield wreckage in the grim economic climate of the war. The finishing touches of bolts, screws, and vents create the impression of a real, functional war machine.

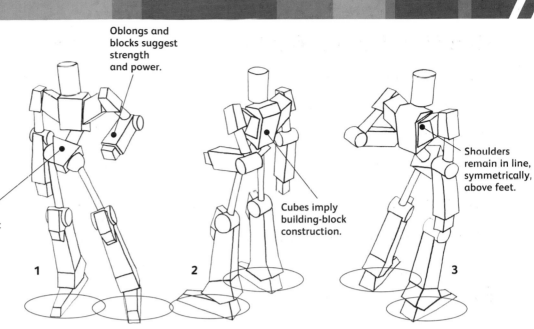

Oblongs and blocks suggest strength and power.

Basic geometric construction.

Cubes imply building-block construction.

Shoulders remain in line, symmetrically, above feet.

1

2

3

Balance

1 Basic shapes in balanced arrangement define the robot's superstructure.

Counterbalance

2 Hip area juts forward, counterbalanced by feet and head.

Alignment

3 Use of an axis to ensure that each extension is counterbalanced by an equivalent extension, for stability.

▼ Irregular profile

All the basic shapes that underlie this robot are drawn freehand to keep a naturally irregular feel to the profile. Don't be afraid to draw as many lines as you want—afterward you can always erase any that you don't need.

▼ Watercolor effects

Watercolor paint (real or digital) is applied in light, loose washes over the pencil, allowing the white paper beneath to show through and giving the color a natural brightness. To create darker areas of tone, paint over the original wash, but avoid muddying the color with too many coats. Use an opaque paint like gouache for additive whites.

Work up the drawing, adding detail and erasing lines that pass behind, to separate masses for an exaggerrated atmospheric perspective.

Sharp pencil defines edges and adds shading to enhance solidity.

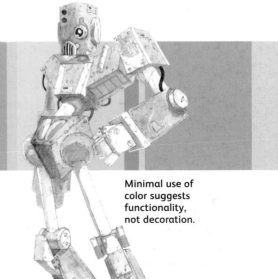

Minimal use of color suggests functionality, not decoration.

▲ Directional light

To create a feeling of light coming from a particular direction, imagine which surfaces face the light source. Alternatively, set up an action figure toy and use a spotlight on it for reference.

As the ideal of the new-and-improved laborer, an urban robot may be expensive, but seeing that they work hard and well in any environment, and all without the slightest complaint, they have rapidly taken over in most sectors. **Adopted by wealthy companies** and governments, these robots have changed the way the city works. **Purely utilitarian,** remember that these robots are all function and no fashion. **Use warning labels,** dust covers, and rusting and worn metal to decorate.

Devloping ideas
Urban robots will have very apparent utilitarian functions made evident in their appearance. Their tools of the trade will have to be fine tuned and adjusted by the artist during the sketching phase.

▲ Here, the artist has played around with different drill bits and connectors, while developing the visual vocabulary for the robot.

◄ The original head had a soldierlike appearance, which was scrapped in the more developed version.

► The mouth belched exhaust, but its appearance was decided to be too aggressive in the subsequent version.

URBAN
ROBOTS

This front view shows the blocky profile planned for the final design.

In this side view, the robot is depicted in action, performing one of its set functions.

The rear view gives excellent detailing on the legs, and how they work.

GARBAGE COLLECTOR

From all angles
Developing a rough cartoon of your robot is an excellent way to familiarize yourself with the fundamental appearance and mechanisms of your creation.

See full image for context.

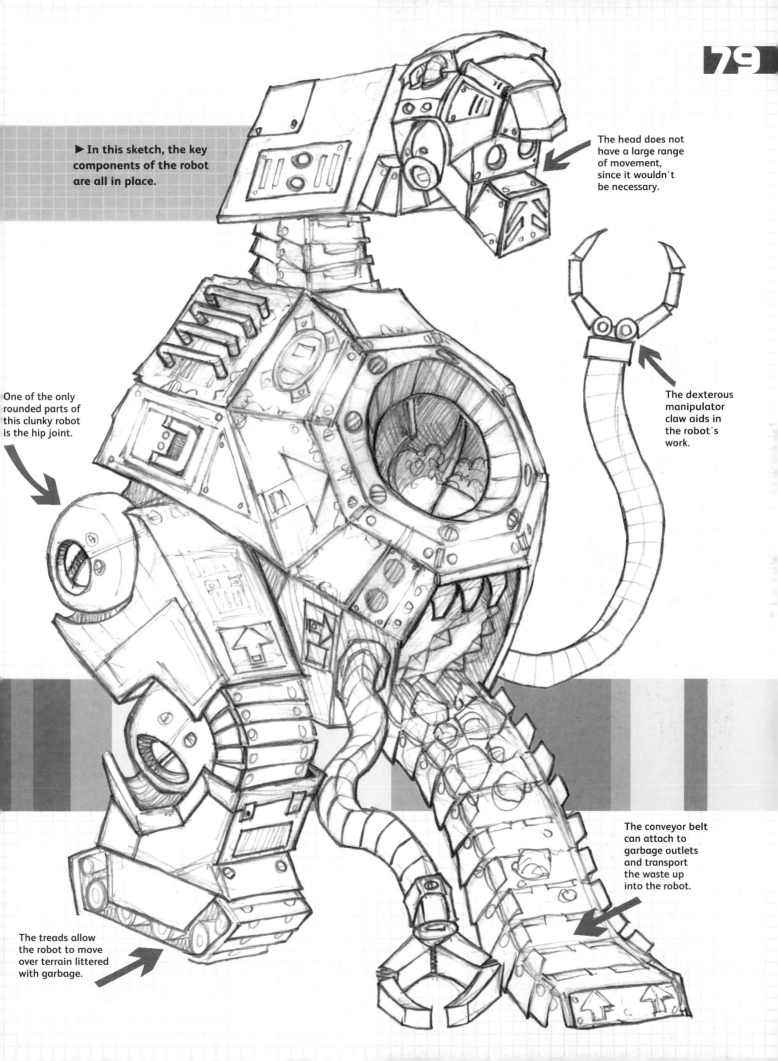

▶ In this sketch, the key components of the robot are all in place.

The head does not have a large range of movement, since it wouldn't be necessary.

The dexterous manipulator claw aids in the robot's work.

One of the only rounded parts of this clunky robot is the hip joint.

The conveyor belt can attach to garbage outlets and transport the waste up into the robot.

The treads allow the robot to move over terrain littered with garbage.

80 NANOBOT

Shaped from proteins, this robot travels through human bodies performing delicate surgery and, alternatively, delivering minute payloads of poison to enemies. **"Nanobot"—of molecular** or atomic scale—is something of a misnomer; this robot is actually only microscopically small, but it can work on a subatomic level. **Wholly organic, the Nanobot** can self-destruct to be absorbed by the host's circulatory system, leaving no detectable trace.

SEE ALSO
Artistic Rendering, **p.16**
Life Is Your Palette, **p.21**
Developing Your Ideas, **p.26**

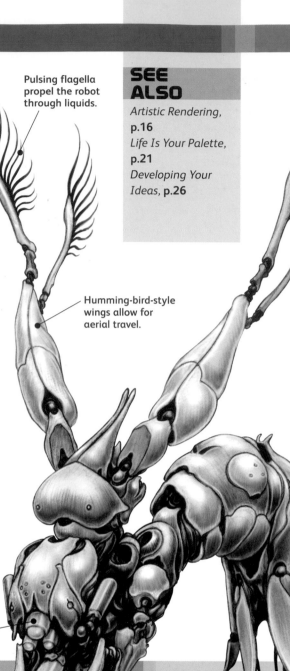

Pulsing flagella propel the robot through liquids.

Humming-bird-style wings allow for aerial travel.

Multiple sensors detect all manner of trace elements and energies.

Lifelike systems
The flagella glow with heat as a by-product of the energy fed through them. As they work, they glow with a brighter and more intense hue. Their shape can be compared to any other organic, microscopic flagella, as on small sea creatures.

Hands can be remotely controlled by a human operator.

Fingertips are complex multitools that can fashion substances on a subatomic scale.

When not needed, elastic arms remain bunched in lumps on the body's surface.

Take inspiration from life
This robot is obviously inspired by microscopic organisms rather than by the usual mechanistic influences.

Right way up
While suspended in liquid and functioning at a scale that makes gravitational considerations difficult, the Nanobot still has limbs that affect its center of gravity. Certainly in design and in direct human application, this robot definitely has a "right way up."

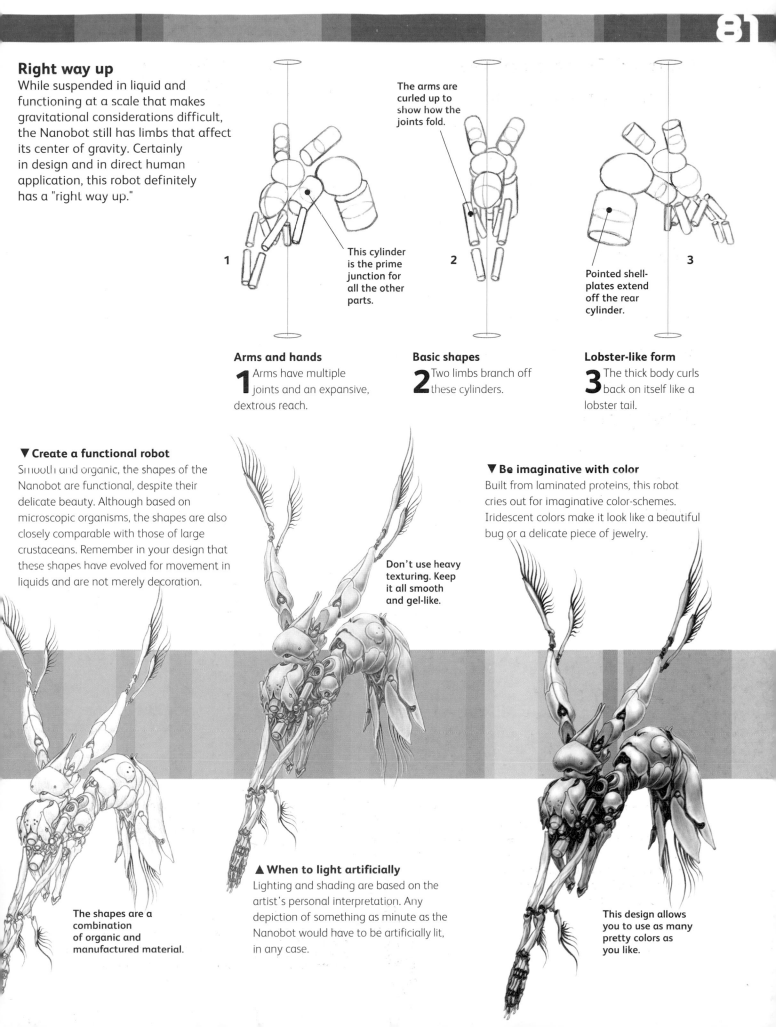

1

The arms are curled up to show how the joints fold.

This cylinder is the prime junction for all the other parts.

2

Pointed shell-plates extend off the rear cylinder.

3

Arms and hands
1 Arms have multiple joints and an expansive, dextrous reach.

Basic shapes
2 Two limbs branch off these cylinders.

Lobster-like form
3 The thick body curls back on itself like a lobster tail.

▼ Create a functional robot
Smooth and organic, the shapes of the Nanobot are functional, despite their delicate beauty. Although based on microscopic organisms, the shapes are also closely comparable with those of large crustaceans. Remember in your design that these shapes have evolved for movement in liquids and are not merely decoration.

Don't use heavy texturing. Keep it all smooth and gel-like.

▼ Be imaginative with color
Built from laminated proteins, this robot cries out for imaginative color-schemes. Iridescent colors make it look like a beautiful bug or a delicate piece of jewelry.

The shapes are a combination of organic and manufactured material.

▲ When to light artificially
Lighting and shading are based on the artist's personal interpretation. Any depiction of something as minute as the Nanobot would have to be artificially lit, in any case.

This design allows you to use as many pretty colors as you like.

86 S19 SYRINGE SAINT

Increasing amounts of **urban conflict** and a rising population in areas prone to natural disasters created a demand for a quickly deployable victims' aid robot. **The S19 Syringe Saint** is fitted with five articulated air jets that keep it afloat as it steps nimbly across hazardous ruins, scanning the area for the injured with its array of sensors.

Segmented body plating to minimize dust and dirt from fouling internal systems.

The fifth air jet is on the back. The four seen on the front act as stabilizers.

SEE ALSO

Rendering Materials, **p.20**
Developing Your Ideas, **p.26**
Bits and Widgets, **p.32**

Long arms that can unfold to become even longer.

Mouth part carries many independent sensors to read the environment (for example, to detect gas fumes and biological contaminants).

Arms are multi-jointed to better reach down into rubble.

Long legs with wire ratchets (intended more as stabilizers than support).

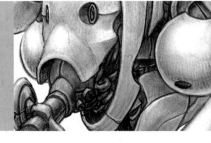

Head detail

Robots will often show glimpses into more internal parts, which usually look quite complex. These internal components should appear as though they stretch back into the body and are integral to parts the viewer can't see.

Conceptualizing the robot

Before you begin, decide on the kind of "feel" you want your design to reflect and what you want your robot to be capable of. This will give you direction. This artist wanted to make a robot that was light and ethereal, that floated and tiptoed about with its sterile white shell. It needed long, dexterous arms to reach people trapped inside rubble.

Constructing the robot

Heavyset robots usually have problems with believable articulation of limbs, whereas thin robots need extra effort to ensure limbs look strong enough to function properly. Organic curves are a great way to solve this problem because they've often developed in nature to efficiently absorb shock and stress. These basic curved shapes are your building blocks start by drafting or tracing these shapes.

Get the balance right

1 Pose is midmovement, so the axis of balance tilts in the direction of travel. This tilt is tricky because the robot is also half-floating (torso almost lifts the legs up).

Conveying movement

3 Think out the robot's movement. This lurch looks odd but not predatory; the robot has direction and purpose.

Using ellipses for basic construction

2 The only true spheres appear on the shoulders. You can keep the organic shapes vague, but remember the volume (denoted by ellipses in the wire frame parts).

The first set of elbows are here (the arms are folded back during movement).

Head rests back into the body.

Hip plate.

Shoulders made up of true spheres.

1

2

3

▼ Creating the linework

Line is very important on sleek robots. Use a blue Col-Erase pencil to sketch light constructional shapes. It's easy to erase pencil after scanning but harder to work on places missed at the pencil stage. Scan the art at a high resolution, erase pencil lines, then drop it down to the desired dpi.

Multiple source, ambient light makes cast shadows. Use Dodge and Burn tools to modify the shading.

Use red and yellow in the shadows.

Light reflects off local parts.

Scanned-in image has been cleaned up.

Details are added to the basic structure.

▲ Masking and shading

Set drawing layer in Photoshop to Multiply and fill in masks of color on a layer below (separate it into foreground, midground, and background). Use the Magic Wand to select areas to work on, then Dodge and Burn to modify the drawing's tone. Shade according to the robot's material.

▲ Coloring the robot

Use Photoshop's Color Balance adjustment to add red and yellow to the shadows and midtones. Place a layer over the drawing set to Soft Light, and the color will glaze over the drawing. Add the "garnish," in this case the play of light and added LED effects.

84 INDUTEX URBAN RENEWAL BOT

A municipal council commissioned this robot from a foreign multinational to combat urban blight. **The Urban Renewal Bot** fills an omnipurpose maintenance and repair role in cities. **Fully modular,** it can be fitted with an unlimited range of equipment and features limited AI (artificial intelligence), which allows it to speak to pedestrians in a soothing, female voice.

A series of latch clasps shows where large, modular additions can be fitted before deployment for carrying out a variety of tasks.

SEE ALSO
Artistic Rendering, **p.16**
Joints and Movement, **p.30**
Bits and Widgets, **p.32**

Articulated arm unfolds. The robot can extend the arm platform up to eight times the current height.

Internal parts viewed between segments would probably be obscured by dustcovers during actual operation.

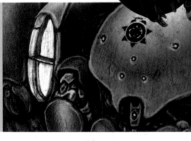

This series of limbs is merely a repetition of the basic, multi-use claw, and any of these can be replaced individually with task-specific heads.

Entire chassis can deform and stand up to allow it easier clearance into tight spaces or to spread out to form a more stable base.

Municipal finery
A shorter set of stronger limbs is located below the forward set of sensors. These are used for heavier, more industrial work, such as road- and foundation-laying. The city's Urban Beautification Association's crest adorns the hood.

Workhorse stylings
This robot is not used in combat but still has to be made of resilient materials to cope with its arduous tasks. A slightly worn and pitted plastic forms much of the casing.

Buglike and functional

Strange and insectile, this robot is nonetheless a helpful and constructive creation, and its posture should make this apparent. While it is four-wheeled like a car, the front wheels are extensions of two articulated arms and are not constrained by a shared axle.

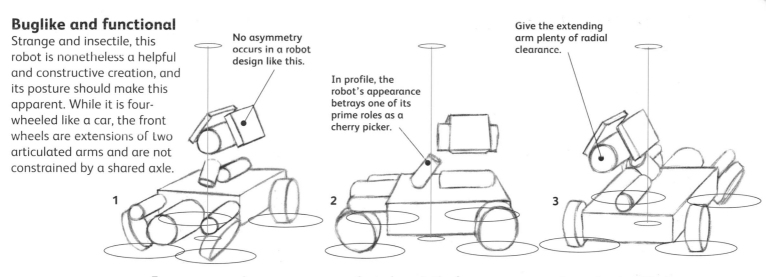

No asymmetry occurs in a robot design like this.

In profile, the robot's appearance betrays one of its prime roles as a cherry picker.

Give the extending arm plenty of radial clearance.

1

2

3

Frame versus casing

1 Whereas the casing is organic, the basic chassis and structural frame are quite geometric in form, not differing greatly from that of a present-day automobile.

Central arm is the focus

2 The main part of the robot is simply a bed for the large, folded arm.

Approximate with shape

3 Because the top arms are rested in a position flush with each other, they are shown here approximated as a simple shape.

To separate the materials from each other, elements such as the tires and rear casing should be darkened overall.

▼ Tightness and looseness

Loosen up on the plastic casings, but ensure that the more structural shapes such as the wheels and rear compartments are tightened up.

▼ City-state colors

Being a civilian robot that performs public duties, the URB gives the artist a good excuse to apply a purely aesthetic paint job (perhaps the official colors of the city-state).

Even though much of the detail would be hard to see when the robot is operating (the tire treads, internal cables, and joints, for example), they're still fundamental to the design and so shouldn't be skipped.

▲ Smooth the shading

Keep the shading smooth and flowing but, as you are drawing beaten-up plastic, you can loosen up occasionally and add a little variance in the surfaces.

A serial number is included for servicing and identification purposes.

82 FACTORY-LINE WORKER

This Factory-Line Worker is a project designed to curb widespread corporate use of "Third World" labor and sweatshop practices. Mounted in a mechanical frame, **genetically cultured** "high-wear" parts are grown in vats and regularly replaced. Not only are the **meat components** cheap to fashion and replace, they are extremely efficient in operation.

Four eyes used by CPU to coordinate assembly and work processes.

CALLING ALL ARTISTS

Leave details like decals, labels, and textural effects to the very end of the illustration process. In this case, the blood vessels, bruising, and chipped paint were the final touches added. Don't overdo these effects, or you may overwhelm your design.

Docking bay connects worker to recharge stations and assorted heavy machinery.

Nutrient cocktails and preservatives pumped into organic parts prevent rot and rigor mortis.

Reactor core encased in thick sphere of titanium alloys to prevent explosions or leaks in case of accident.

Hazard pattern to alert human workers.

Showing wear and tear
One of the main points of interest in this design is the juxtaposition of organic components with harsh, industrial ones. Details such as the chipped paint on the metal are matched by the rashes and engorged capillaries on the flesh.

Feet are toughened, and mechanically reinforced but often need to be replaced daily.

Emotional reactions
Although not aggressive in any way, this robot is unsettling to the viewer. Designed solely for industrial purposes, the Factory-Line Worker is distinct from a military or civilian robot. Imagine it as run-down and neglected, serviced by technicians who have no real concern beyond keeping it functioning.

A humanoid drone

The main form of the Factory-Line Worker is humanoid. Of course, the proportions have been twisted and skewed (especially in the mechanical sections). However, the underlying layout and jointing remain human in effect. A great weight seems to crush the body down into a slumped posture that shows it operates in an environment where there is little concern for its health.

SEE ALSO

Rendering Materials, **p.18**
Life Is Your Palette, **p.21**
Developing Your Ideas, **p.26**

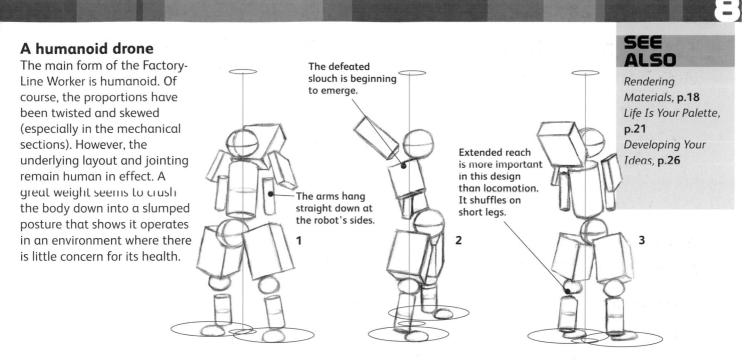

The defeated slouch is beginning to emerge.

The arms hang straight down at the robot's sides.

Extended reach is more important in this design than locomotion. It shuffles on short legs.

Contrast the materials

1 Note the contrast between the geometric metal parts and the rounder flesh parts even at this stage.

Balance the mechanism

2 The extremely heavy sphere in the abdomen counterweights the back block.

Focus on details

3 The legs have more distinct jointing because they're more mechanical than the arms.

▼ Poignant character details

An especially poignant effect is achieved in this design by emphasizing the strangeness of the human parts mounted in the cold, lifeless shell. Hard, industrial shapes make an excellent complement to the disturbingly familiar limbs.

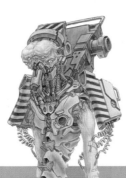

Keep those hazard lines striking by darkening them to almost absolute black.

▼ Utilitarian design

This is an industrial robot, so try to convey a functional "utility" feel in the color-scheme. The bright, striped hazard markings vitalize the design, as do the warm hues of the bruised flesh.

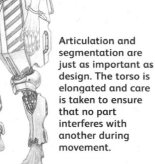

Articulation and segmentation are just as important as design. The torso is elongated and care is taken to ensure that no part interferes with another during movement.

▲ Shading tips

Make a distinction when shading the differing materials that make up the robot. Simply put, the flesh should be lighter and softer than the metals.

The paint job is purely functional. Balance this with some attractive organic variations in the flesh.

88 GRUNTER

The Grunter was obsolete before it was even finished. Too big and cumbersome for most environments, the ten Grunters that were originally manufactured were soon decommissioned by the army and sold to private companies. The model shown here is the last survivor, having served for three hundred years as a salvager on the colony worlds.

SEE ALSO

Working Digitally, p.14
Artistic Rendering, p.16
Joints and Movement, p.30

Horizontal pistons control forward motion; vertical pistons lift legs.

Sensor arrays analyze salvage content and value.

Head houses two maintenance robots.

Main body contains compactor and furnace for breaking down salvage.

Air vents clog and need to be cleaned regularly.

On its last legs
The concept is a robot in a state of advanced decay and disrepair—a fragile machine, despite its bulk. Leave the edges scratchy and sketchy to emphasize decay.

Surface details
There is a lot of surface detail, so try using a program such as Painter for the shading rather than crosshatching in pencil, which will make the detail too hard to read.

Years of wear
After the salvage is compacted and melted down, it is categorized and stored in the abdomen. This means that the surface of the robot will be pitted and damaged by 300 years of wear and tear.

Sturdy design
1 The enginelike core of the body is perfectly balanced and supported by the hinged, slightly bowed legs. Although the robot itself is very old, the underlying construction remains strong and sound.

Timesaving 3-D options
2 Use 3-D software and save yourself hours of perspective drawing. You'll find it easy to construct your basic robot using default shapes in a perspective view.

Functionality
3 Any jointed hinging you create will affect the way the robot moves. Robots are mainly functional. Construct your robot with care, visually conveying information about the robot's movement.

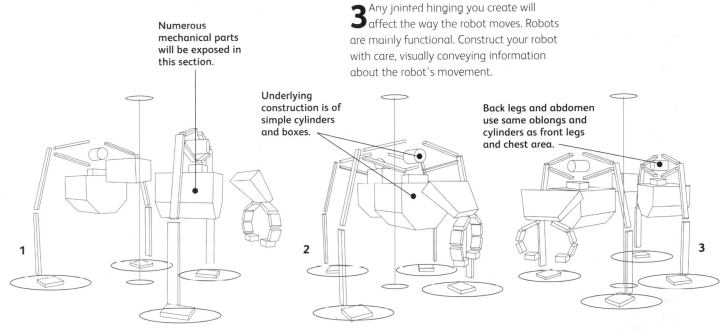

Numerous mechanical parts will be exposed in this section.

Underlying construction is of simple cylinders and boxes.

Back legs and abdomen use same oblongs and cylinders as front legs and chest area.

1

2

3

▼ 3-D options
The robot is a mess of crammed together shapes and surfaces: flat, curved, sharp. There is nothing smooth about the Grunter. Linework is reminiscent of engine parts and other intricate, but convoluted, machinery.

Quadrupedal construction means weight distribution is less of an issue.

Three centuries of toil create the impression of a walking scrapyard.

▼ Color and contrast
Choose earthy, dull colors to emphasize the age of the robot. Use red on the lenses in the head as a contrast to the duller tones.

World-weary exterior contrasts with inner fire in eyes and belly.

▲ Layers
Apply your color flat on a Multiply layer, and then add highlights and details on a new layer.

Law-and-order robots, used for policing, are unique in that their interaction will be primarily with the civilian populace. **They are human-friendly** but have a disconcerting potential for violence beneath the surface. **Though not engineered** to be attractive, the appearance of these peace-keeping robots is nonetheless important. **They have been** painstakingly designed both to calm a crowd of agitated rioters and to intimidate and terrify wayward suspects.

Developing ideas

Robots whose roles lie in law and order have similarities to military robots, but their aggressive aspects may be downplayed. One major consideration is how public the robot should be in its appearance; it could bear official markings or function in a more "plain clothes" role.

▲ An aggressive stance implies a robot who means business.

◀ The artist tries out different head designs.

▶ Shoulders are flanked by rubber appendages.

LAW&ORDER
ROBOTS

This rounded port is where the prisoners are transferred from the robot.

This panel will be the barred cell gate in the final design.

The chest is huge because it is mostly a cavity.

PRISONER-CONTAINMENT ROBOT

From all angles

This illustrative rotation of the robot shows its exaggerated posture and its large chest. Notice that the joints are developed even at this stage.

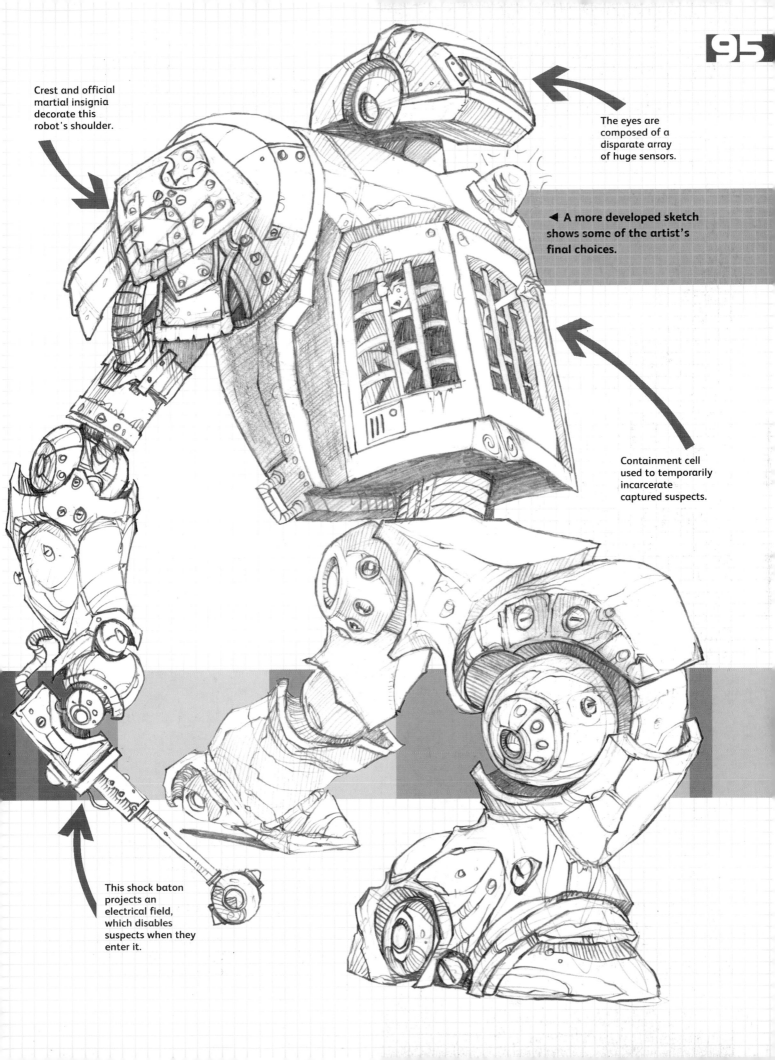

Crest and official martial insignia decorate this robot's shoulder.

The eyes are composed of a disparate array of huge sensors.

◄ A more developed sketch shows some of the artist's final choices.

Containment cell used to temporarily incarcerate captured suspects.

This shock baton projects an electrical field, which disables suspects when they enter it.

92 OFF-WORLD TRADER

The alien-looking Off-World Trader (OFT) droids were designed by EarthAid Cybernetics as a means of infiltrating the civilizations on colony worlds to source vital food supplies for sale back on Earth. **The OFTs are programmed** with one million colonial bartering protocols and are multilingual.

Recessed head contains a high-definition, heat-sensor, and night-vision cameras.

Slouching, primeval shoulders create a hunched and suspicious profile.

SEE ALSO

Working Digitally, **p.14**
Rendering Materials, **p.18**
Joints and Movement, **p.30**

Articulate hands with delicate fingers enable the Trader to type at computer terminals and participate in auctions.

Exoskeleton can be modified with clip-on plates for protection in hostile environments.

Brains and brawn
The recessed head is set into powerful shoulders that house an extra-large "Calculus" brain designed to process millions of complex transactions a second.

Unusual design
The strange form of the robot includes an almost monkeylike upper body, biomechanical tentacles for product testing, and ultrastrong legs.

Tapered knees, bulging calves, and feet like hooves, give the Trader a racehorselike quality.

Consumer aid

The Off-World Traders were an offshoot of the first line of Radian checkout robots, which were designed to carry bags of food and consumer goods through war-devastated streets to the homes of needy civilians.

Sketch the shape first before working up the design using your software.

The shapes used create an impressively dramatic silhouette.

Note how the legs are bowed to indicate tensile strength.

1

2

3

Experimental shapes

1 Experiment by bending and warping your shapes when doing your initial figure doodles.

Elegant motion

2 Looking at the ball-and-socket joint of the hip, we can get an idea of the sinewy way the OFT walks.

Powerful build

3 Strong upper body has a yokelike structural reinforcement for carrying heavy loads.

Two-tone color-scheme is a chance to explore color combinations.

▼ Highlights

Accurate lighting aids realism. Think about where the light will fall on the robot's curves as the low evening sun strikes him from behind.

Mix and match as many color combinations as you want. Try blue and light gray, or red and white—the options are endless.

▲ Shading

Use dark lines to define the shadows, which will help depict which elements of the design are round, flat, or square, just by placing the shadows correctly.

Satin-metal texture is imperfect, suggesting wear and tear.

▲ Extra rendering

The white fogging on the legs and tentacles integrates the robot with the scene, whereas a shadow can plant him firmly to the ground so he does not look like he is floating.

90 NAKATOMI CLERK

The Nakatomi Clerk hovers above the marble floors of corporations and embassies, greeting people with its computer-generated human personality. **Fully customizable,** the Clerk fills a myriad of roles, and its impeccable manners and on-the-fly networking capabilities have led many executives and dignitaries to admit that they now prefer dealing with Clerks to networking with people.

Nakatomi Corporation logos,

This computer-generated representative is an embassy diplomat for the Tatar Mercantile Republic.

Externally assisted magnetic induction levitates the robot, which is able to float only in magnetically facilitated buildings.

Sets of hands for physical interaction.

Docking port for instant connection with other robots and humans.

Drawing computer imagery
Artificial lighting illuminates the computer-generated figure, and scan-lines are overlaid as an illustrative device to indicate that she is presented onscreen (and not sitting inside the robot!).

Form equals function
Illustrating this style of robot creates unique considerations for the artist because of its lack of resemblance to other, more familiar forms (humanoid, vehicular, and so on). Being a civilian robot designed to deal with people and put them at their ease, it is important to create a nonthreatening, servile form.

Design a realistic machine

Although this robot floats, that does not mean that its axis, balance, and relation to the horizontal plane (in this case, the floor of the lobby) are irrelevant to its design. The robot pivots on the bottom section, so ensure that you illustrate a believable hinge mechanism and balance. The general shape of the robot should almost resemble the consumer electronic appliances that we use everyday without a second thought.

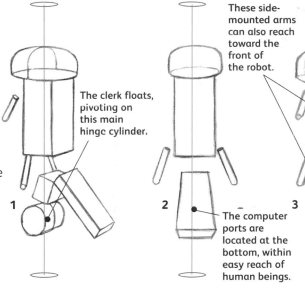

The clerk floats, pivoting on this main hinge cylinder.

1

These side-mounted arms can also reach toward the front of the robot.

3

The computer ports are located at the bottom, within easy reach of human beings.

2

Extending arms

1 These arm cylinders are folded up on themselves and can double in length.

Simple shapes

2 Note how simplified the design can become and yet remain recognizable.

Vision

3 Because the robot can see in any direction, the arms are tucked back from the screen so as not to impair vision.

Try to think ahead to the painting stage and what is in danger of becoming obscured.

▼ Shading and light
Choose a shading style to show that the brushed metal plating reflects light differently than the self-illuminated screen.

▼ Industrial art
Clean, attractive colors suggest a robot that an industrial artist could have spent time designing. The colors of the on-screen personality are closer to the colors used in a classical painting than in a photograph.

Later on, lighting and color will work to differentiate the screen from the robot.

▲ New line styles
The linework requires a slight shift of style between the smooth, sharp forms of the robot and the more organic curves of the woman on the screen.

In order to draw attention to the vibrancy of the screen image, keep the robot's colors subtle.

96 STEEL LOTUS TANK CALMER

When the Imperial Chinese land armada stole into Tibet, the holy men of the mountains defended their peaceful land by willing into being fifteen thousand tank-calmer robots, known as "Steel Lotuses." Far from being a killing machine, each robot was **powered by one thousand prayer wheels**. Together the Steel Lotuses swept forty-six thousand Imperial tanks back over the border with the people's collective prayer for peace.

SEE ALSO

Working Traditionally, **p.12**
Artistic Rendering, **p.16**
Attachments and Embellishments, **p.34**

Peace-ray appears as a gun to invading hordes.

Brain powered by 1,000 miniature prayer wheels.

Exhaust system produces minimally hazardous byproducts.

Farsighted design
The eyepiece is an ingenious piece of equipment, allowing the holy men to see through remote eyes in all weathers, day or night. The robot also has olfactory sensors to smell out invaders.

Sturdy multijoint leg-units, weighted for extra stability.

Harmonious elements
These beautiful robots moved effortlessly across the landscape. The holy men allowed a handful to fall into Imperial hands, secure in the knowledge that the invaders could only understand the prayer-powered mechanisms by first accepting the message of peace.

Shapes and balance

This design is essentially a tapered cylinder on legs. Constructed in segments, it decreases in diameter toward the rear where it curves upward to form the exhaust. Oblongs and triangles in the legs create a visual contrast.

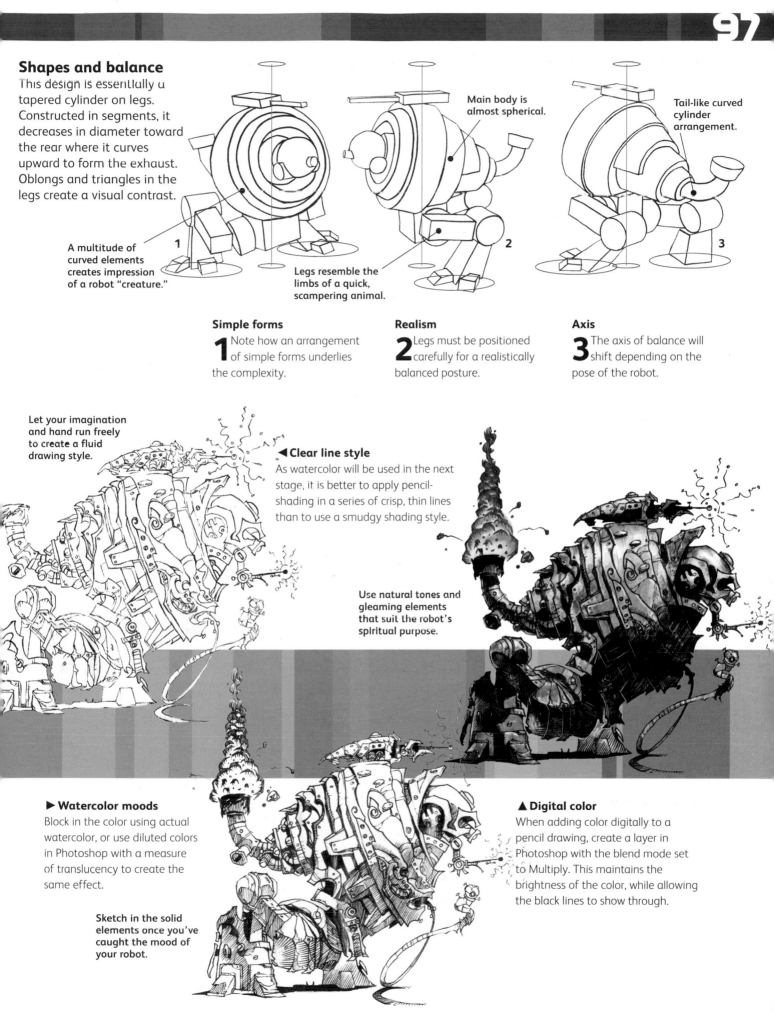

Main body is almost spherical.

Tail-like curved cylinder arrangement.

A multitude of curved elements creates impression of a robot "creature."

1

Legs resemble the limbs of a quick, scampering animal.

2

3

Simple forms

1 Note how an arrangement of simple forms underlies the complexity.

Realism

2 Legs must be positioned carefully for a realistically balanced posture.

Axis

3 The axis of balance will shift depending on the pose of the robot.

Let your imagination and hand run freely to create a fluid drawing style.

◀ Clear line style

As watercolor will be used in the next stage, it is better to apply pencil-shading in a series of crisp, thin lines than to use a smudgy shading style.

Use natural tones and gleaming elements that suit the robot's spiritual purpose.

▶ Watercolor moods

Block in the color using actual watercolor, or use diluted colors in Photoshop with a measure of translucency to create the same effect.

Sketch in the solid elements once you've caught the mood of your robot.

▲ Digital color

When adding color digitally to a pencil drawing, create a layer in Photoshop with the blend mode set to Multiply. This maintains the brightness of the color, while allowing the black lines to show through.

98 THE EXTERMINATOR

By the late twenty-fifth century, most humans had given up their organic heritage and become cybernetic organisms. **The few remaining** Bioforms were forced to hide away or face immediate extermination. **The elite cyPods** were not allowed to pollute themselves with filthy biological matter, so a hit squad of flying robots was pressed into service to finish the job for them: the Exterminators!

SEE ALSO

Working Traditionally, **p.12**
Developing Your Ideas, **p.26**
Bits and Widgets, **p.32**

Wings act as guidance foils.

Antigravity generators housed within body casing.

Stabilizing rods filled with gyroscopic adjustors.

Heat-sensitive "seeker" organ, mounted on gripper proboscis.

Tail ends in sensor cluster.

Deadly armory
The primary tools of the Exterminator's trade are its claw-tipped arms. Other weapons can be attached as well, including flame throwers, electron-pulse cannons, and heat-seeking killer-virus grenades.

Monstrous creations
Created by their masters to resemble insects and other creatures that terrified Bioforms, Exterminators became fond of adorning themselves with gruesome trophies from their hunting expeditions.

Distinctive shapes

Each Exterminator is a challenging collection of contrasting shapes—flattened and distorted oblongs, spheres, and cylinders. The finished design is very distinctive, so think carefully about construction.

Aerodynamic lines

2 No need to think much about balance when drawing the Exterminator. Instead, give it an impression of speed and maneuverability in the air by focusing on its sleek, aerodynamic lines.

Axis for flight

3 The axis for a robot in flight is different from a regular, land-based creature.

Plated arrangement takes inspiration from real-world insects.

Hand shapes have oddly human aspect.

Nothing natural

1 The underlying shapes may be insectlike, but the construction is distinctly mechanical, sharp, and sinister. If this robot is an insect, it is an aggressive, deadly one.

Distorted oblongs suggest mechanical elements.

1 2 3

▼ Appropriate style

The drawing style is jagged, jittery, and detailed to create a sense of insectile complexity and advanced machine engineering.

Ink chosen to define edges and enhance solidity.

◄ Multiply mode

Scan into Photoshop, then create a new layer and set the mode to Multiply. Add color with Pencil, Brush, and Airbrush tools and adjust using the Color Balance, Hue/Saturation and Brightness/Contrast menus.

Iridescent colors suggest insectlike parts.

Drawing was scanned before adding color and texture in Photoshop.

► Experiment with color

When adding color in a program such as Photoshop, you have an amazing amount of freedom to adjust or alter the color in any way you like. It is also easy to create new color variations on the underlying drawing itself.

100 MARTIAL QUELLER

As the multinationals gain ever-increasing power, they also face greater hostility. Their aggressive weakening of federal powers has relegated much policing to being handled internally. **The Martial Queller** is used to put down protests and riots, and its mere presence acts as a deterrent to those who would fight the authorities. **Whenever corporate** property is threatened, the Martial Queller wades into crowds, vomiting tear gas and shattering dissidents with its electric baton.

SEE ALSO

Rendering Materials, **p.18**
Attachments and Embellishments, **p.34**
Military Attachments, **p.36**

Plated communications array maintains constant satellite communication with corporate HQ.

Chemical canisters fire tear-gas and other suppression shells into crowds.

Silk-fiber-composite plating in a blastproof shield, which is also magnetically shielded to protect the robot from directional EMP (electromagnetic pulse) blasts.

Nonmilitary tough guy
Although heavily armored and aggressive, this robot is not a military device, so you can expose areas between the armor plating. The humanoid warrior design creates the impression of a "corporate Samurai," ever loyal to its lord—in this case the board of directors.

A weave of rubber strips encases an explosive charge, which is detonate the robot finds it mobbed by overwhelming numbers of civilic

Implying strength
Hexagonal plating implies great strength in the shield's makeup. Polygonal shapes are an excellent way to create attractive, yet technically believable large surface areas in robotic design.

High-powered electric baton with plastic splash-shield (to prevent bodily fluids from shorting the open electrodes).

Powerful pose

A squatting warrior pose can be used to great advantage in this robot. Its shield is also shaped and sized for use in protecting the torso without obstructing the already heavily armored legs.

Torso design

1 As with many robots, its lower torso and pelvis are relatively thin and mostly structural.

Aggressive aspect

3 Both the shield and baton are held away from the body in a defiantly aggressive display posture.

Tilting shields

2 The shoulder plates are tilted forward to deflect bullets away from the torso.

The shield doesn't differ fundamentally from this simple rectangle; a section has merely been cut out.

Though the arm connects with the shield at the elbow, it still continues in length as a structurally strong mooring.

The baton is held at the midway point, but can slide forward for extended reach.

1

2

3

▼ Inorganic shapes

Although curved, the shapes used in the design are not quite organic, giving an industrial and unpleasant aspect to a robot that's more brutal than it is sophisticated.

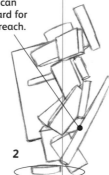

▼ Officer robot

Use of blue, white, and yellow add to a police-officer-like appearance, which has been adapted by the leasing companies to maintain the identifiable color-schemes of the old authorities.

The hexagons are keyed in with the elements they touch (notice how other elements seem to line up with them consistently).

Note how the hexagons will be laid in later with the aid of the computer (don't bother with a ruler).

▲ Perspective on details

Darken the muscular cable bundles that can be seen in the gaps between the armor plating so that they "sit back" from the viewer's eye, creating the impression of a glimpse into the anatomy of the robot.

The modular riot-shield and baton do not share the same color-scheme as the robot itself.

In the age of the globalized Unified Church, heresy has ushered in a new Inquisition. **It's in this** crisis that a robot like the Purger must play the dual roles of spiritual healer and cleanser of heathen communities. **Whenever a heretical** movement is detected, the Purger is sanctioned to descend on the community at night, cutting down men, women, and children, burning everything to the ground to cleanse the land of sin.

A personal satellite floats around robot, offering reconnaissance and detailed sensory information to its host.

Holy symbol of the Unified Church branded on the Purger's forehead.

SEE ALSO
Decals and Logos, p.20
Developing Your Ideas, p.26
Attachments and Embellishments, p.34

Enlarged sheath and bayonet array.

Fixed flamethrower with bayonet and tank of compressed, jellied napalm.

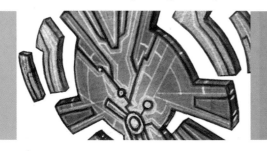

Complex circuitry
The satellite is almost Art-Deco style in aspect. The satellite is designed to be a completely unarmored entity with almost bare circuitry, indicating that it's packed with complex sensors and electronics.

Fierce and fearless
"Intimidating" sums up the impression you want to create with this design! The majority of combat takes place at very close quarters, resulting in the Purger's predatory appearance—and its large complement of blades.

Electrically motivated razor wires with bayonet heads thrash and flail around the robot.

The fear of God

The Purger is a bogeyman: designed specifically to instill dread from every angle, even with its profile and the shapes of its body parts. Bristling with knives, and with a bare skull sunken into the hulking torso, the Purger is a twisted, humanoid design. Playing more of an assassin's role—with its target being unsuspecting civilians—this robot is more agile looking than it would be if it had a heavily armored, military appearance.

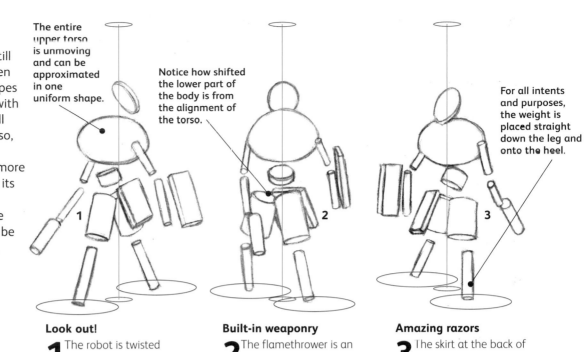

The entire upper torso is unmoving and can be approximated in one uniform shape.

Notice how shifted the lower part of the body is from the alignment of the torso.

For all intents and purposes, the weight is placed straight down the leg and onto the heel.

Look out!

1 The robot is twisted round to its left, as if looking over its shoulder.

Built-in weaponry

2 The flamethrower is an extension of the forearm rather than a limb section replacement.

Amazing razors

3 The skirt at the back of the robot houses twin rolls of razor wire.

▼ Bug like segments

A strange, insectile segmentation is used uniformly in the design—in marked contrast to elements like the satellite and flamethrower.

Much of the robot is pliable and, therefore, has an organic quality to its component shapes.

▼ Regal colors

Use an opulent color-scheme here to imply the almost regal status invested in the robot by its owners, who've obviously poured incalculable funds into its creation.

Darken the far leg dramatically to separate it and place it in perspective.

▲ Hateful pate

A darkened mass of wriggling shapes swells up to the bare, skull-like head of the robot. The distinct, metallic sheen of the blades is applied at the coloring stage, so leave out bold highlights at this point.

Notice how the head texture and color shifts slightly from the rest of the robot, almost resembling bone.

ROBOT FOUNDRY: LAW AND ORDER

104 ORBITAL DELEGATE

This robot is an exhaustive overhaul of the second Soviet Space Program's **cosmonaut buddy system**. Mounted with independent and solar power sources, and equipped with **dual gauss guns**, the Orbital Delegate now circles the earth shooting down any satellites that contravene sanctions and treaties.

While not combat armored, the robot is plated for protection from asteroids and space debris.

SEE ALSO
Drawing and Research, **p.10**
Artistic Rendering, **p.16**
Attachments and Embellishments, **p.34**

Docking extension for connecting to its service space station.

Extensions unfurl into huge solar collecting panels.

Coil guns mounted in dual setup for more controllable recoil.

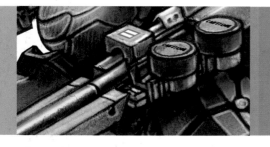

Legs terminate in complex retro-boosters.

Don't design a heavyweight
These mechanisms seem slender and delicate when placed beside the large robot. However, in space, the only real stresses to the guns are caused by firing them. Their design is linear and specialized, but certainly not robust by terrestrial weaponry standards.

Flower power
The Orbital Delegate does not need to be a rugged robot, as it floats in the vacuum of space. It is an astro-artillery piece rather than a machine designed for combat. Additional parts and equipment blossom out of it like petals on a flower.

Zero-gravity design

Due to its environment, the Orbital Delegate encounters no gravitational stresses and strains. Its limbs function only as articulation and are not load bearing. The exception is the arms, which connect the guns to the torso and need to be relatively reinforced. This is one of the rare cases where axis and ground plane are not vital factors in your design.

Zero-atmosphere considerations

1 Remember this robot floats but doesn't fly, so its profile is not aerodynamic.

Points to remember

2 This robot is very specialized, so full articulation and maneuverability are not really necessary.

Designed for its environment

3 The robot moves in an unnatural but precise manner, totally unlike a human, leaving its profile inorganic.

The two coil guns are completely identical, as are their mountings.

The body position is not symmetrical but also not dramatic, as it drifts in a vacuum.

These two main cylinders run right through the middle of the torso, bisecting it.

1

2

3

▼ Space robots

Space is an environment totally different from that in which most robots will have to function, and this will be reflected in every aspect of your design. Satellite and space station shapes and proportions are excellent sources of reference here.

▼ Environmental hazards

Use reflective whites and metallic colors, including golds, in abundance. On the robot they would prevent extreme overheating from the sun's rays. Glowing lights and LEDs resemble those of satellites and contemporary space technology.

Even the large flat planes in this design should have a slight degree of ambient shading.

▲ Getting the lighting right

Although not wholly accurate to the sharply contrasting lighting of objects in space, your shading should lean toward a basically realistic portrayal, balancing realism with the need to maintain interesting detail.

The shapes of this robot are a result of its complex structure and serve no outward purpose.

Bright and metallic, the colors of the Orbital Delegate resemble other pieces of machinery and space debris that spin in the Earth's orbit.

106 BOUNTY HUNTER SHK 300

In the future, hardcore policing is entrusted to machines. **Their impassive minds** are foolproof insurance against corruption in the police force. **The Bounty Hunter Search-Hunt-Kill (SHK) 300** deals with the most dangerous criminals. **It operates with great stealth,** and can engage in extended pursuits that would not be humanly possible.

The SHK 300 uses an autonomous AI and, when needed, it can quickly connect with the central police mainframe. **This robot is deployed** when a judicial decision has been made. **Often, the target** is executed on the spot.

SEE ALSO

Rendering Materials, **p.18**
Joint and movement, **p.30**
Attachments and Embellishments, **p.34**

Satellite dish establishes uplink for data on current bounties.

Differently colored head and plating denote recently replaced parts that have yet to be camouflaged.

Curved, hunched profile creates a smaller target for small-arms fire.

Metal claws grip with a force of four-hundred pounds. SHK 300s have been known to rip the arms off fleeing criminals while in hot pursuit.

Plating is heavy on the front of the robot, as this is the most probable direction for absorbing incoming fire.

Death's head
The SHK 300's head can move freely to aim at anything in its field of view. Its intricate targeting systems are concentrated at the sides of its face and neck, as are its deadliest weapons: two linked pulse guns, one long-range laser, and one nonlethal ballistic disabler.

Simple purpose
This robot was designed to display its sinister function, and its predatory and hunched posture illustrate this role. Concealment being important, the robot was designed with a camouflaged paint job in mind (something that can, if not carefully planned, create a muddled image).

Shoot first

The shapes are strictly functional. It must move quickly, shoot accurately, and withstand the harshest conditions. The robot is fitted with jump jets allowing for short periods of limited flight. With the help of smaller articulated jets, it can make very complex and unexpected maneuvers.

The hunchback of interstellar space

1 The Bounty Hunter is humanoid with a dominating, curved, armored profile and a hunched back.

Animal-like

2 The long barrel shape above the legs acts as a forward hinge to allow the Hunter to leap onto all fours at a moment's notice for swift, catlike movement.

Core stability

3 Although hunched in shape and stance, the robot has a very stable structure.

The hull contains the central computer and is curved to deflect enemy fire.

This Bounty Hunter is organic and insectile in design.

Simple leg shapes will become animal-like later.

1

2

3

Create every section on a separate layer so you can easily change only those areas of the robot you dislike.

▼ Layers and light

When you're satisfied with the linework and have committed it to one layer, the next stage is adding color and volume. Fill in the layer under the linework. Choose your light source carefully, and let it guide you when you start adding your color.

▼ Layers and detail

The final application of details can be the most time-consuming phase. Flatten all layers to one for painting ease. Use the zoom function to add very fine details. To make the robot appear used and worn, create a new layer on top and paint on some scratches and stains.

Shade and color several variations of the robot, compare, and choose the best.

Add some camouflage patterns and markings for an additional element of interest.

▲ Digital drawing

Though the whole image is done in Photoshop, the first stage is always freehand linework. The best thing about drawing on the computer is the possibility for changing the picture throughout the creative process without loss of quality. You can easily zoom in and add fine details.

08 SAMURAI GUARD

The Samurai Guard is a repurposed military robot converted for private, civilian use. **The civilian model lacks** the built-in weaponry of the military version but retains some of the armor plating and ECCM (electronic counter-counter-measures) protective systems. **The head is separate** from the body, held in place with a proprietary antigravity/ electromagnetic system. **This allows the robot** to use the head as a floating remote camera.

SEE ALSO

Working Digitally,
p.14
Artistic Rendering,
p.16
Rendering Materials, p.18

This sensor actually extends during use, and can retract during combat.

The face mask is decorative, and clients who desire less aggressive appearances for guard duties tend to have the factory default replaced.

The clothing is primarily composed of synthetics and is designed to rip easily to prevent opponents from using it as a combat advantage.

The KEIGO personal security robot
This particular consumer model was designed with integral armor and joint protection built into its "clothing." Its proportions also preclude it wearing human clothing. Commercial retailers often customize the robot's face plate.

Decorative intimidation
The KEIGO was planned to resemble a fearsome statue standing still in a room during a sensitive meeting, causing the intimidated to fret over the likelihood of this statue suddenly springing to life and attacking.

Plated robotic parts match the hue of the synthetic cloth.

Human nature

This robot, like the others, can be broken down into simple shapes such as cubes and cylinders. The design of this robot is intended to resemble the human body but with exaggerated proportions that emphasize its massive stature.

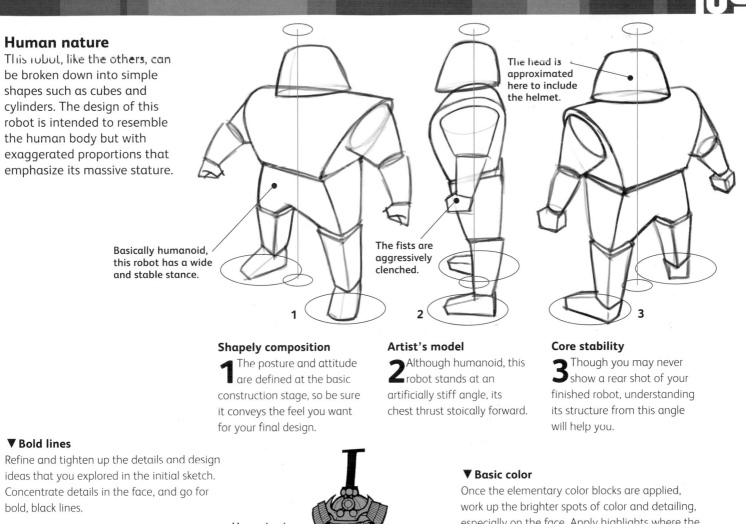

The head is approximated here to include the helmet.

Basically humanoid, this robot has a wide and stable stance.

The fists are aggressively clenched.

Shapely composition

1 The posture and attitude are defined at the basic construction stage, so be sure it conveys the feel you want for your final design.

Artist's model

2 Although humanoid, this robot stands at an artificially stiff angle, its chest thrust stoically forward.

Core stability

3 Though you may never show a rear shot of your finished robot, understanding its structure from this angle will help you.

▼ Bold lines

Refine and tighten up the details and design ideas that you explored in the initial sketch. Concentrate details in the face, and go for bold, black lines.

Use a simple light and dark color-scheme.

▼ Basic color

Once the elementary color blocks are applied, work up the brighter spots of color and detailing, especially on the face. Apply highlights where the light shines on the downward facing surfaces of the head. Add a subtle wash of warm color over the whole painting.

Indicate the glow of the levitating device in the pit of the neck with a strong highlight.

For visual unity, make sure the graphical motifs repeat through the design.

▲ Background

In your digital painting program, lay down a rectangle of a warm red, orange, or brown color in the background. Then try painting the robot in complementary hues.

Many great robotic advances will be made in the consumer electronics market and tomorrow's robotic grenadiers may well be today's robots designed to walk the family dog. **Pleasant in appearance** and adapted to a variety of tasks, these robots are a boon to humanity. **Although personal helpers** have smiling, approachable faces and are very user-friendly they incorporate all the high-tech design and intricate robotics you would find in the most cutting-edge machine.

Developing ideas
It's a good idea to sketch out simple examples of your helper robot interacting with domestic human objects in the kinds of settings the robot is intended for.

▶ An early prototype has only two arms.

▲ This sketch captures the arm movements.

▶ This variation is recognizably human in appearance.

ASSISTANT
ROBOTS

The helper robot may even take on human gestures such as resting its hand on its knee.

The hip pivots in movement, just like a human's does.

MULTIARMED ROBOT

From all angles
Helper robots give the artist a wide range of probable approaches. When designing, remember that your robot will have to interact with people.

Wheels instead of legs just didn't seem to match the dexterous upper body.

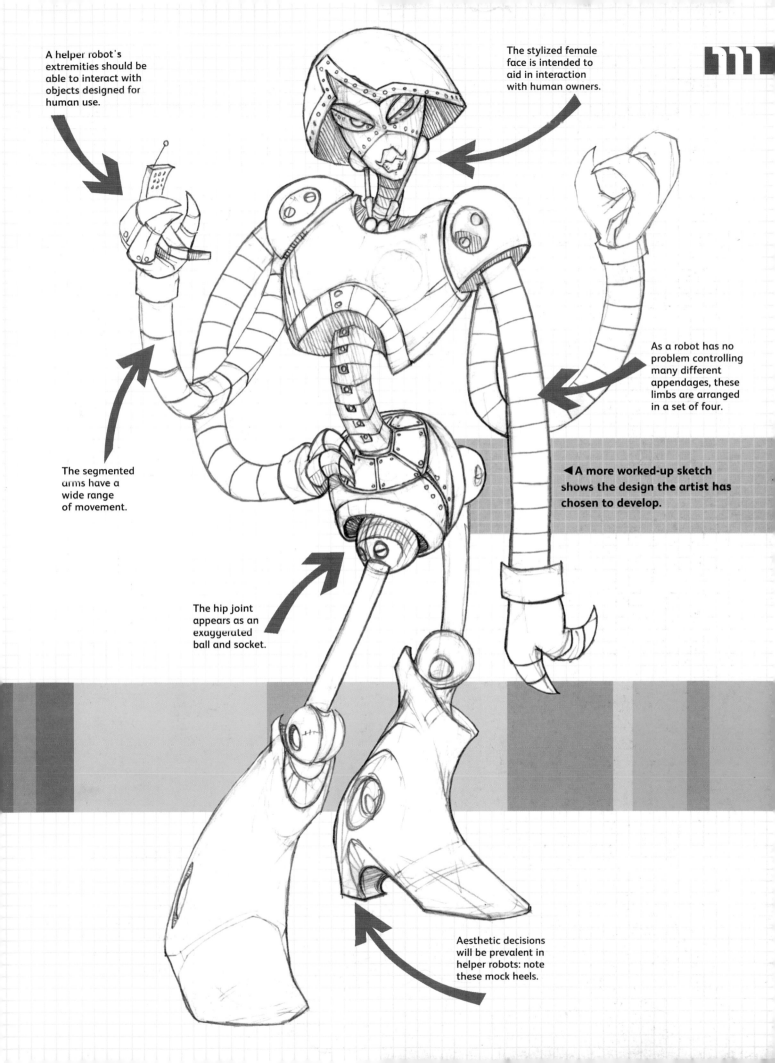

A helper robot's extremities should be able to interact with objects designed for human use.

The stylized female face is intended to aid in interaction with human owners.

The segmented arms have a wide range of movement.

As a robot has no problem controlling many different appendages, these limbs are arranged in a set of four.

◄ A more worked-up sketch shows the design the artist has chosen to develop.

The hip joint appears as an exaggerated ball and socket.

Aesthetic decisions will be prevalent in helper robots: note these mock heels.

112 ADIUVO MARK IV

The ADIUVO Mark IV is the most advanced consumer personal-assistant robot in the Adiuvo range, which began in the late twenty-first century with the original toylike Adiuvo I (see page 43). **The current model** has greatly expanded functions and abilities and is often used in civil and industrial situations as well as in its intended domestic role.

SEE ALSO

Life Is Your Palette, p.21
Joints and Movement, p.30
Bits and Widgets, p.32

The ceramic/resin material allows organic, esthetically pleasing, humanoid shapes to be mass-produced.

The humanoid proportions and size of this ADIUVO model allow it to wear human clothes when necessary.

Lightweight ceramic/polycarbonate resin exoskeleton.

The exoskeleton is slightly flexible, but joints are still needed in the exterior skin to allow full range of movement.

Humanoid rhythms
The overall design is intended to resemble the human body; the facial features and expression should also. Use the eyes to mimic a human gaze.

Simple construction
This robot can be broken down into simple shapes such as cubes and cylinders, which makes it easy to draw.

Off-axis stance

Push the boxes and cylinders off the vertical axis. The weight of the robot still needs to be centered, but its body can lean and introduce gentle curves and "S" shapes into its standing pose.

This robot can move subtly and convey meaning through humanlike touches such as a slight turn of the head.

Mimic a strong, masculine body type.

Use humanlike joints and your robot will be able to make humanlike gestures.

1

2

3

Shapely shapes

1 By gracefully rounding the elementary shapes used, the robot is able to move in a fluid, human way.

Artist's model

2 Make use of a wooden artist's model when drawing the Mark IV. Models are available at any fine art store.

Core stability

3 Like a human, your robot needs a strong spine and a pelvis to enable an upright carriage and a strong stance.

Segmentations and other design elements should echo human anatomy.

▼ The right tone

Once the basic forms are rendered, adjust the color and saturation, but keep it subtle to allow the saturated spot-colors in the eyes to stand out. The different shades will emphasize certain muscle groupings as well.

Overall design should retain a friendly appearance.

With the color blocked in, you can alter the hue and saturation if you wish.

▲ Superhuman

The linework on this robot is essentially of the major muscle groups of the human body. Leaving these muscles exposed gives the ADIUVO Mark IV not only a human but a "superhuman" look. Use anatomical charts to get the muscles just right.

▲ Finishing

The addition of dark, almost black, joint material adds a 3-D quality to the robot. Spectacular highlights and glowing green eyes complete the design.

114 KARAKURI

The seventh Tokugawa, a great patron of Karakuri design during the Edo period, commissioned this robot. Used to entertain guests with its charming grace as it carefully presents its hosts with tea, the Karakuri has also been used sparingly in **Japanese Noh theater**, much to the shock of the audience when they discover that the masked actor is a robot.

SEE ALSO

Drawing and Research, **p.10**
Developing Your Ideas, **p.26**
Joints and Movement, **p.30**

Tea for the host and his guest is presented on a lacquered tray.

Two pneumatic pumps function as the Karakuri's prime mode of movement.

Large lacquer box contains the cogs and switching-boxes that control the air tubes that lead to the Karakuri.

Geisha-girl robot
The wig and face resemble a warped impression of a Geisha. The hair is real and has to be tied back and arranged in the traditional fashion, just like a real woman's. Details such as the heightened eyebrows and tight lipstick are applied to already-pale porcelain.

Tanned skin tubing delivers compressed air from the main pumps.

Delicate functions
With a design that's purely for show, the Karakuri performs only simple tasks; its primary role is to charm guests. Resembling a life-size doll in dress, the Karakuri is also constrained by the limits of how far the tubing will reach from the engine that powers it.

Shinto charms are fixed to the engine box and are said to help instill the Karakuri with a soul.

Humanoid figure

The robot is distinct in that it can be approximated as an elongated human figure. Basic structure and articulation are fundamentally humanoid, so employ your life-drawing skills to do justice to the figure's gestures.

Tube connections
1 The figure and the engine are separate, connected only by tubing.

Posture and legs
2 Note the permanently bowed posture and legs that don't lock straight.

Characteristic stance
3 A delicate, feminine posture is an important element in creating the impression desired by the artist.

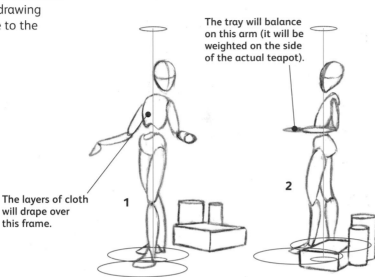

The tray will balance on this arm (it will be weighted on the side of the actual teapot).

The layers of cloth will drape over this frame.

The laquered box and cylinders are kept somewhat simple, so they don't detract attention from the actual robot.

▼ Pattern considerations
Don't be too concerned with patterns on the kimono at this point—it would be far too much trouble to carry these through. Patterning can be applied in raw color at the end of the process.

The black lacquer is defined by the tiniest application of shine on sharp edges and points of highlight.

▼ Creating porcelain
The porcelain skin is of the palest white, like that of a courtesan or Geisha, and this starkly contrasts with the rich colors and patterns of the kimono.

Tiny touches add disproportionate interest, such as the Geisha-style lipstick application.

▲ Heavy contrast
Heavy degrees of contrast are starting to develop at this point—for example in the balance of dark hair and black lacquer with shining porcelain and gold.

Some influences (especially in the face) have been taken from the stylized ukiyo-e woodblocks of Japan.

This legendary living statue is sculpted from clay and instilled with holy life to function as a servant to its creator and as a protector of the community. The writing on its forehead gives it **the spark of life** and removing part of this inscription can deactivate the Golem. Although it makes an excellent assistant, a **Golem** is apt to get stuck in loops and perform the same tasks over and over again.

SEE ALSO

Drawing and Research, **p.10**
Artistic Rendering, **p.16**
Bits and Widgets, **p.32**

The Golem's guise is that of an ancient Judaic priest, a sign to people of a Golem's relation to its rabbinical creator.

This eyeball is what the Golem actually sees with, and it swivels and glows as it looks around.

Four arms aid in manual labor.

Metal plates tied to torso with red cloth.

All-seeing eye
Whereas the conventional pair of eyes are blank and deadened, it's the glowing orb of the drawn eye that the Golem uses to see the world. This eye's inner light illuminates and colors the surrounding clay and complements the overall color-scheme.

Creating clay textures
The Golem is a servant created out of clay for manual labor, so try to create a worn, chipped, rugged texture. The Golem is not an aggressor and appears strong and steadfast rather than dangerous.

Spikes in the feet ensure stability.

Doll-like joints

The Golem's shapes and joints are similar in appearance to those of a doll. It adopts a stiff, crudely humanoid stance.

The arm separates into a new segment at the elbow.

The upper arm section is more like a draping sleeve than a body part.

This primitive shape is basically a hoopskirt surrounding a pair of legs.

Ready for action
1 The Golem awaits his orders.

Freedom of movement
2 The ball joints connecting the arm segments allow a wide range of movement.

An imitation of life
3 The design is essentially humanoid, so call on your life-drawing skills.

This robot's surface detailing should reveal imperfections caused by the clay firing when the Golem was made.

▼ Watch your shading
The shading of the clay is consistent over the whole robot.

In this case, the clay has been matte glazed, so the reflections and textures should be neither too shiny, nor too dull.

The central glowing blue highlights areas of orange glazing.

▲ Materials
Hard, chipped, earthen shapes are required here, so keep things organically rough and uneven. Keep in mind, however, that all the elements are quite stiff and unyielding. Consistency is important to ensure that the Golem's headdress, for example, is obviously made of the same material as his skin, and so on.

▲ Defining substance with color
The clay is well-worn, chipped, and glazed with deep, warm hues. Exceptions are the reflective metal breastplate, red ties, and the glowing blue eye. The metal chest plate reflects the colors around it.

118 WITCH PUPPET

An Obeah servant of a witch, fashioned from wood, bronze, and gourds. Wholly subject to the will of its creator, a Witch Puppet is usually deployed for menial tasks and is kept out of sight.

A monkey has been sacrificed so its spirit can inhabit each limb, and human remains are encased in the head to manifest a controlling spirit. Folktales tell of a time when **Witch Puppets** destroyed whole towns in a matter of minutes.

SEE ALSO

Drawing and research, **p.10**
Artistic Rendering, **p.16**
Developing Your Ideas, **p.26**

Eyes on the mask are closed; the puppet sees through the painted third eye.

Scythe for reaping the witch's harvests.

Branch from a cemetery tree fools the captive soul into thinking of the puppet as its rightful resting place.

Second pair of arms ends in long, sharp fingers for threshing millet.

Cured gourds, hollowed and used as key parts.

Tanned skins drawn tight over bowed, wooden frames.

Bundles of tied grasses.

Spry, strong saplings used as feet.

Period pieces
Remember to keep the materials in your design consistent with this ancient robot's time and setting. For example, this curved wooden crest is bound by grass twine, and the spine is made from stained, interconnecting wooden vertebrae. In your version, all of these materials should appear worn and well used.

Organic and constructed parts
Almost wholly fashioned from gathered, organic parts, this robot's only artificially made elements are its blades and baubles. As with other puppets, all motion and strength are derived from outside forces (in this case, magic), which leaves it strangely proportioned.

Texture emphasizes character

Most of the Witch Puppet is composed of lightly fashioned, organic shapes, so take a look at real twigs and grasses for inspiration. Sections—like the tree branches—can be drawn to resemble bones, emphasizing the puppet's deathly nature. Remember to keep a design like this sprightly, however, so that the robot appears light on its feet, rather than heavy and machinelike.

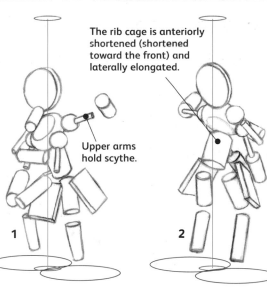

The rib cage is anteriorly shortened (shortened toward the front) and laterally elongated.

Upper arms hold scythe.

Lower set of arms is in a resting position.

1

2

3

Arranging limbs

1 Be careful not to make the four arms too jumbled. Care has been taken in their arrangement to allow them a full range of movement.

Functionality

2 These primitive elements are the keys to designing a strange, but plausibly functional, body type.

Arms and shoulders

3 A laterally elongated torso provides a mount for the arm and shoulder rotation.

▼ **Craftsmanlike colors**

Colors are all warm and dry: stained wood, dried grass, and plant material. The colors are influenced by traditional African arts and crafts.

▼ **Care with shading**

Remember not to obscure the textures (the blades of grass, the grains of wood) when applying your shading. The wood is stained, but not varnished, so don't make it too shiny.

Loosen up when drawing this robot. Remember that these materials have been grown, not manufactured.

▲ **Deliberate looseness**

The linework is loose, but it's not careless. The notches and imperfections in the lines should appear deliberately organic, not messy.

Most of the design is quite dark. Keep key points, such as the face, pale as a contrast.

Use deep, organic colors, especially on the metals that have begun to rust.

120 GENTLEMAN GARDENER

SEE ALSO

Drawing and research, **p.10**
Rendering Materials, **p.18**

Revealed in 1770 to the amazed court of George III, the Gentleman Gardener was a gift from the French monarchy at the end of the Seven Years' War. **The robot's creator** was thought to be an apprentice of Jacques De Vaucanson (1709-1782) the great automaton builder. **Sadly, the robot was destroyed** in 1785 by the King who, in a fit of madness, was convinced that the robot was mocking him in French as it raked the leaves.

The head is lacquered wood—light, but resilient to weather and wear and tear.

Incapable of speech, the Gentleman Gardener whistles several popular tunes as he works. Powered by bellows in his chest cavity, he seems to breathe between songs.

To protect the delicate workings inside the robot, the coat is treated, waterproof leather.

Programmed activity
The glass-fronted chest piece has a secret lock mechanism to allow access to the clockwork interior. A rotating device inside holds a variety of task-specific cartridges. With a little study, it is possible to alter the information on these cartridges manually and reprogram the robot.

The hands and wrists are fully articulated and move realistically. Hands can open, close, and grip various tools.

The arms and legs are padded with straw to "flesh" them out.

Secret mechanism
Hidden within the roller is a steam engine to aid locomotion. The Gentleman Gardener isn't strong enough to push such a weight and is merely the means to steer it.

The feet never fully leave the ground. A concealed metal wheel is always in contact with the earth for purposes of electrical conduction.

Lifelike machine

The design was influenced by automaton designs of the 18th and 19th century. The craftsmen of this time strove for an "imitation of life" and desired to create realistically human machines using the materials at their disposal.

In order to convey a sense of motion, make the robot lean forward very slightly.

The arms are mechanically symmetrical, revealing the true inorganic nature of the robot

The weight is distributed mainly onto the front foot.

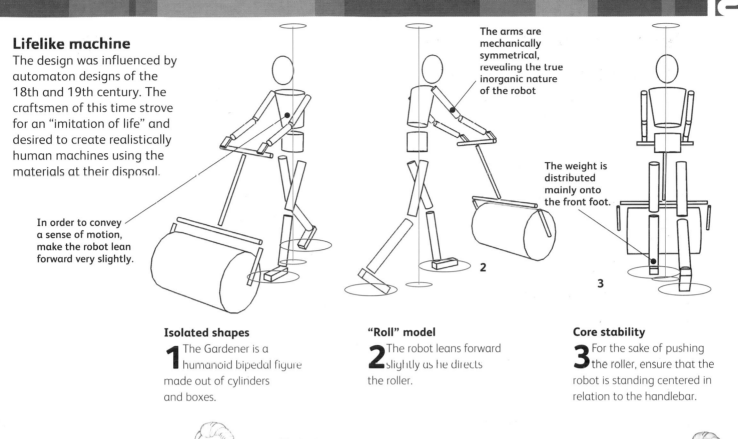

Isolated shapes

1 The Gardener is a humanoid bipedal figure made out of cylinders and boxes.

"Roll" model

2 The robot leans forward slightly as he directs the roller.

Core stability

3 For the sake of pushing the roller, ensure that the robot is standing centered in relation to the handlebar.

▶ Linework

The drawing was done with a standard draftsman's pencil (HB).

▼ Shading in Painter

For shading, use an acrylic drybrush in Painter. This brush gives a nice grainy texture and is especially good for clothing. Over the linework, color a multiple layer in 60% gray.

Use gentle shading for most of the design as there are no high-contrast metals present.

Add an overlay to bring out the contrast between the shiny metal and the duller cloth materials.

Ensure that the roller is symmetrical and carefully constructed; it's the kind of device that can immediately look strange if slightly skewed.

▲ Traditional coloring

Apply an earthy palette layer in a flat color. Do some color research to identify the colors that would have been in popular use during the time period. Afterward, use a drybrush to add color variants such as the heavily rouged cheeks and lips.

122 DOMESTIC ANGEL

The Domestic Angel was the darling of the Ideal Home Exhibition in 1951. **The working prototype** was a glimpse into the future that few could resist. **By the end of the 1950s**, this robot was a common feature in suburban households. **The inventor, Otto Braunwald**, died mysteriously in 1960. **Some say that** he was silenced before he could reveal the otherworldy origins of his technology.

SEE ALSO

Working Digitally, **p.14**
Rendering Materials, **p.18**
Bits and Widgets, **p.32**

The halo glows when the Angel speaks or repairs are needed.

A rubberized face can be chosen from a catalog of both male and female faces and easily fitted onto the robot. Celebrity faces are available.

The computer controls all domestic chores. Tapes and updates are reasonably priced. French cuisine is one of the biggest sellers.

Voice comes from a speaker imbedded in the chest.

The iron is a standard fitting on every Angel. It is always ready-heated and stored in the chest cavity.

Mechanic vs. organic
This design is very period oriented, and very little mechanics were intended to be visible. The head has an unsettlingly disconnected feel to the rest of the body.

Retro inspirations
The main theme for this robot was 1950s American futurist design. The Angel was engineered to be functional and believable, while still retaining its retro sci-fi look.

The rail can be fitted throughout the entire house, allowing total automation of chores.

The housekeeping accessories are only available to the robot if it is positioned directly in front of them. This is a safety feature added after the fire of '57.

Made to measure

Resembling a basic kitchen appliance, the robot is stock straight and firmly anchored despite its humanoid appearance. Extremely specific functions are illustrated by the robot's planned structural limitations, lack of reach, and apparent adaptability.

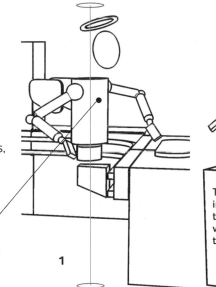

The trunk cylinder can rotate, giving the robot access to any part of the kitchen counter.

The neck is inclined forward to better allow viewing of the counter.

The winglike protrusions on the back borrow design elements from automobiles of the same period.

1

2

3

Elementary shapes

1 This is a humanoid-shaped robot minus legs, attached to a series of boxes.

Crazy train

2 Because the robot is on rails, weight distribution isn't an issue.

Elbow room

3 Ensure that there is enough turning space for the robot.

▼ Vintage flavors

Chose bright "ice cream parlor" colors to reflect the time period. Apply the color flat on a multiply layer until you are happy with the overall appearance. Add additional highlights and colors on a new multiply layer.

▼ Highly polished surfaces

Use an airbrush in Painter for shading. Over the linework, color a multiply layer in 60 % gray. This will leave you with a polished finish ideal for surfaces like laquered metal, chrome, and formica.

▼ Sketching

At the drawing phase, ensure that you're happy with the perspective and the robot's relation to its environment.

The counter and surroundings should not steal any of the viewer's focus away from the robot.

These two connected planes share the same shade, which links them together in the viewer's perception.

This robot is covered with chrome and other very shiny materials. Use the dry brush to work an overlay layer and bring up the shiny highlights using a palette of the original colors and white.

124 MARINE EXPLORER ROBOT

The undersea world has fascinated man for centuries, but the wonders of its deepest reaches proved impossible to explore until Merbot 5 was developed. **Like a submarine**, Merbots can withstand the pressure of extreme depths, but unlike manned craft these hyperintelligent machines can explore for months without surfacing while blending with the environment and gathering terabytes of data.

Crustacean-like head packs light beams and high-resolution photosensors.

SEE ALSO
Working Traditionally, **p.12**
Bits and Widgets, **p.32**
Attachments and Embellishments, **p.34**

Sample-container strips analyze samples.

Denizens of the deep
Merbots are designed to blend in with their environment, burying themselves in the seabed to escape predators and attracting colonies of coral and crustaceans. Biomechancial fins break up the crablike carapace as Merbot stalks the depths self-generating power like an electric eel.

Disguised hands hide massive array of tools.

Sensitive pincers
Merbot's crablike claws wield a multitude of tools that it deploys to analyze samples using an ecologically sound process that maintains the marine balance.

Biomechanical skin attracts coral growth and crustaceans.

Hyperdense metal alloy withstands enormous pressures.

Functionality

The finished robot still looks like it is made from distorted boxes and other simple shapes. Design flourishes such as spikes, fins, and other features create the impression of functional reality.

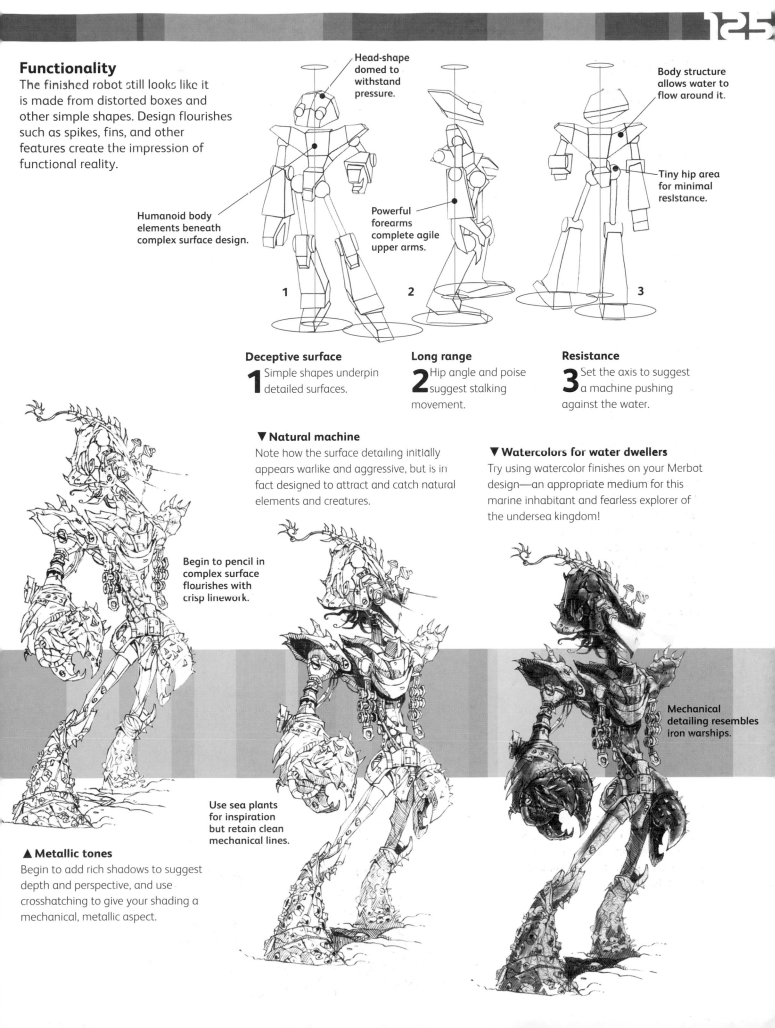

Head-shape domed to withstand pressure.

Body structure allows water to flow around it.

Humanoid body elements beneath complex surface design.

Powerful forearms complete agile upper arms.

Tiny hip area for minimal resistance.

1 Deceptive surface
Simple shapes underpin detailed surfaces.

2 Long range
Hip angle and poise suggest stalking movement.

3 Resistance
Set the axis to suggest a machine pushing against the water.

▼ Natural machine
Note how the surface detailing initially appears warlike and aggressive, but is in fact designed to attract and catch natural elements and creatures.

▼ Watercolors for water dwellers
Try using watercolor finishes on your Merbot design—an appropriate medium for this marine inhabitant and fearless explorer of the undersea kingdom!

Begin to pencil in complex surface flourishes with crisp linework.

Mechanical detailing resembles iron warships.

Use sea plants for inspiration but retain clean mechanical lines.

▲ Metallic tones
Begin to add rich shadows to suggest depth and perspective, and use crosshatching to give your shading a mechanical, metallic aspect.

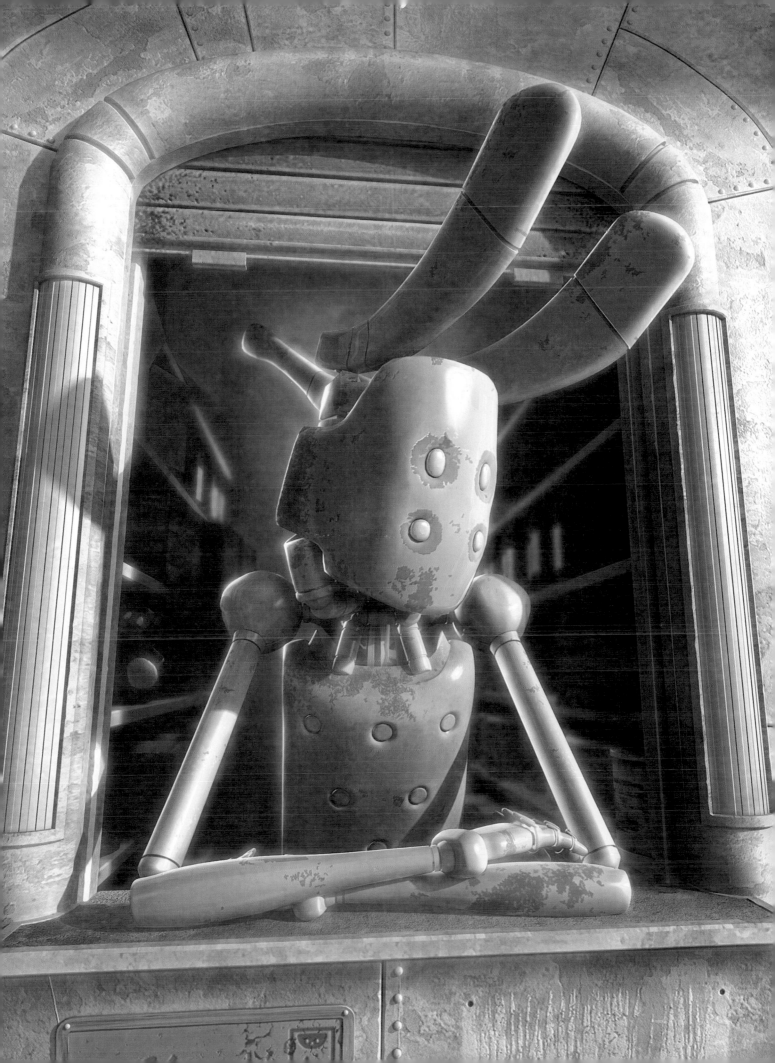

The publisher would like to thank and acknowledge the following artists for supplying work reproduced in this book:

Key: t = top, b = bottom, l = left, r = right, c = center

Roland Caron http://goron3d.free.fr 127; Kevin Crossley www.kevcrossley.com 10, 11b, 40–41, 54, 56–57, 76–79, 94–99, 110–111, 124–125; Thierry Doizon www.barontieri.com 29, 52; David Grant vilidg@vilidg.force9.co.uk 42, 88–89, 120–123; Lorenz Hideyoshi Ruwwe www.hideyoshi-ruwwe.com 48, 50; Rado Javor rado@konzum.sk 53, 106–107; Corlen Kruger www.corlen.adreniware.com 1–5, 27r, 28, 30t, 31t, 32t, 36t, 37r, 44, 47, 51, 92–93; Keith Thompson www.keiththompsonart.com 22–25, 26, 27l, 34b, 35, 55,

58–75, 80–87, 90–91, 100–105, 114–119; Francis Tsai www.teamgt.com 34t, 38–39, 43, 108–109, 112–113, 128; David White www.mechazone.com 45, 46, 49.

The publisher would also like to acknowledge the following: Paramount/The Kobal Collection 9c; Charles O'Rear/Corbis 32bl; Chris Middleton for additional text.

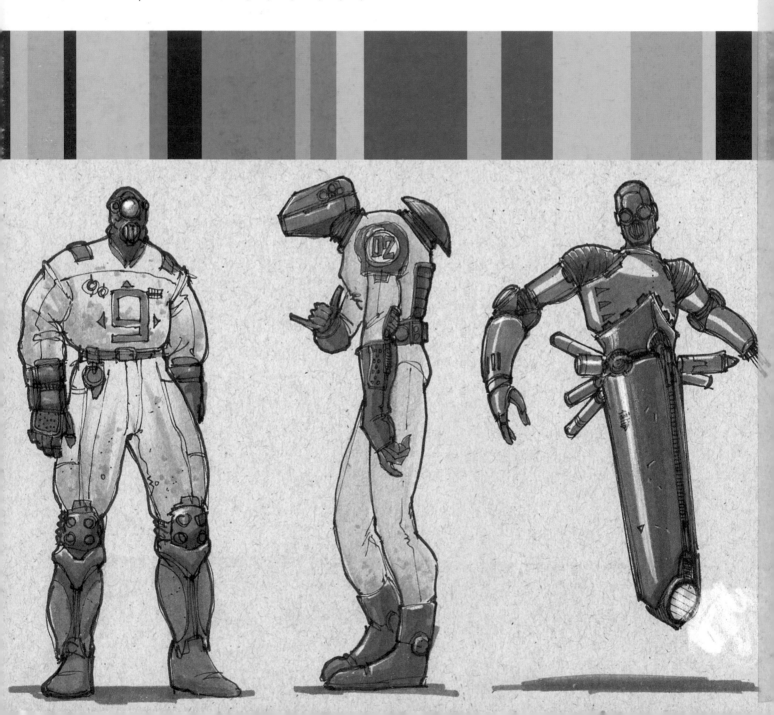